No Excuses Watercolor

PAINTING TECHNIQUES for Sketching & Journaling

GINA ROSSI ARMFIELD

NORTH LIGHT BOOKS
Cincinnati, Ohio
CreateMixedMedia.com

contents

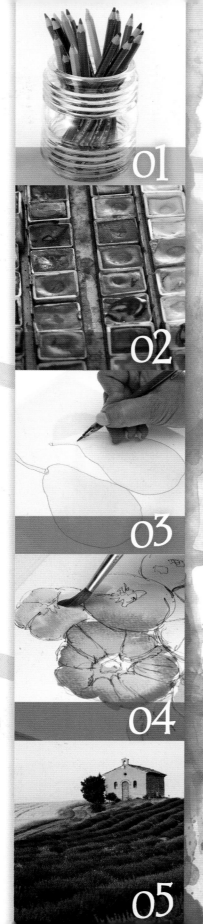

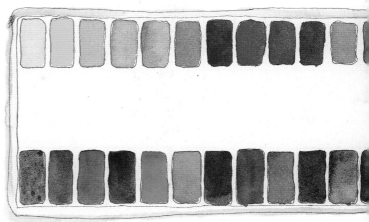

What You Need

eraser
fountain pen
hair dryer (optional)
journals
lightbox (optional)
liquid frisket with dedicated brush
paintbrushes
palette
paper towels
pencils
pencil sharpener
permanent marker
piston converter
reference images
rubber cement pickup
ruler
salt, table and sea
sponge
spray bottle with water
transfer paper
washi tape
water container
water-soluble pastels, pencils and pens
watercolor paint
watercolor paper
watercolor pencils
waterproof ink
waterproof pens

Introduction

Whimsical, wonderful, fluid, frustrating, intimidating, hard to control—WATERCOLOR! Most people love the look of watercolor but are fearful to give it a try because it can be like herding cats. Watercolor does have a mind of its own, so the key is to let go of the tight grip of control and just go with it! In many ways it is just like life; the more you push, the harder it is, and when you allow yourself to move forward with trust, things seem to fall into place.

I have been painting for many years, both in oils and acrylics, but watercolor has become my true passion. I love the way the colors bleed, move, separate, puddle and run. That is the beauty of the medium. I have found that my approach to watercolor can be almost Zen-like once you give in to its beauty and let it do its own thing.

There are many styles of watercolor painting that follow a traditional approach—mine is not one of them! I like to explore and experiment in a fun and fast way that plays with color. My techniques are loose and fluid and allow you to find your own way and style.

In the chapters that follow, you'll learn how to enjoy and play with watercolor paint. You'll get to know your paints with a few fun and simple exercises. Then you'll discover how drawing can make all the difference in whether or not your painting turns out the way you want. After you learn different drawing and sketching techniques, you'll practice a variety of painting exercises to help you find your own painting style. Finally, in the inspiration source guide, you'll find thirteen sections of themed prompts so you can continue to practice your skills.

Not only will you have no more excuses for not painting in watercolor—you'll fall in love with it!

Materials

I am warning you—watercolors are addictive!

They come in so many lush and luminous colors, you may become obsessed. When it comes to watercolors, quality is the key to being, and feeling, successful. Cheaper materials will not give you the same effect and will lead to frustration. My suggestion is to invest in a set of high-quality paints and brushes at the outset. They will last you a very long time. Unlike acrylic paints, which once squeezed out of the tube, dry and then can no longer be used, watercolors can be revived for years to come. I have tried many different kinds and have come up with a method that works well, is easy to travel with and in the long run is cost efficient. The most important thing to remember when purchasing materials is to find ones that you really like the feel of and that match your needs and personality.

But paints are not the only material you need to be successful with watercolor. In this chapter you'll learn about the brushes, paper and other materials you'll need to achieve the effects you want.

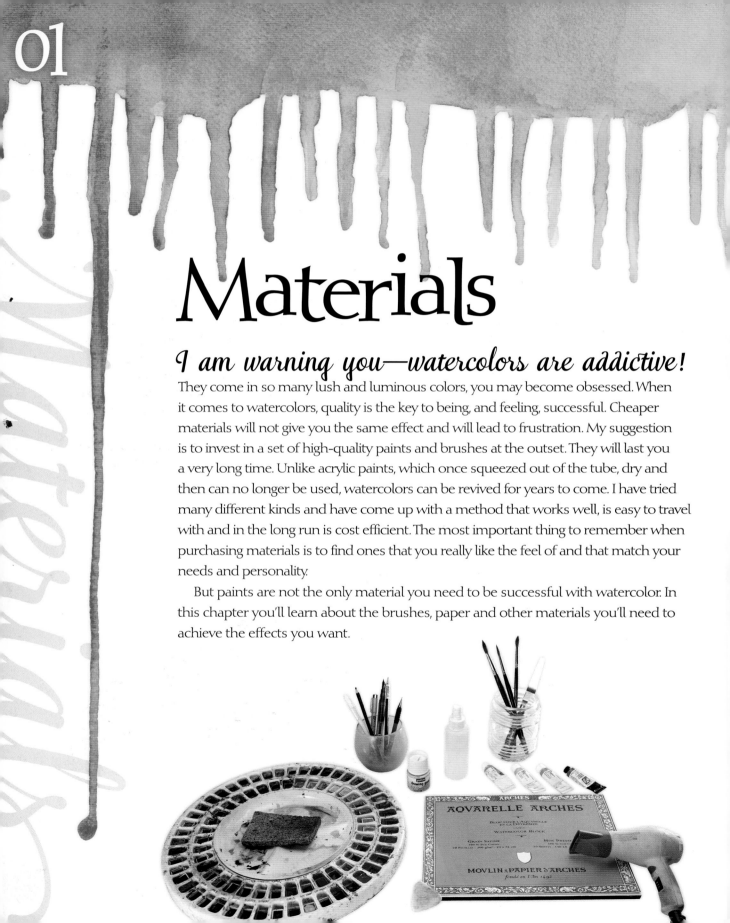

Pens

Pen-and-ink drawings are often the basis for the watercolor work in this book, so it is important to have instruments that do the job well and that you are comfortable with. The most important thing is that they contain *waterproof ink*! If the ink is not waterproof, your drawing will bleed all over the place when you add watercolors. There are many different kinds of ink pens out there. I use different pens for different projects, and each has its own personality and feel.

Technical Pens: There are many brands of technical pens available and each has its pros and cons. These pens have a single nib and are generally all waterproof or are fillable with waterproof ink. They range in nib size from 005 on up. I prefer to use a 005 or a 01 pen, which adds a delicate touch to my contour drawings.

Rollerball Pens: These pens have a smooth, solid flow. They come in a more limited point size and most are not waterproof, so reading labels is especially important when purchasing them.

Fountain Pens: I love to use these pens to sketch! They come in a huge variety of nib and body styles. Some pens are piston filled, which means they have a reservoir already built in with a turn or a plunger for sucking up ink inside the pen's belly. Others are dropper filled, which means that you need to use an eye dropper or syringe to fill the ink well inside the pen.

Lastly, there are pens that come with ink cartridges. Note: *Cartridges are not waterproof.* For fountain pens that come with a cartridge, you must use a piston converter. There are a variety of nib styles ranging from extra fine to broad as well as a flex nib that varies the thickness of the line when pressure is applied to the tip. I prefer extra-fine and flex nibs for sketching.

White Gel Pens: White pens can be used over watercolor paint to create areas of highlight.

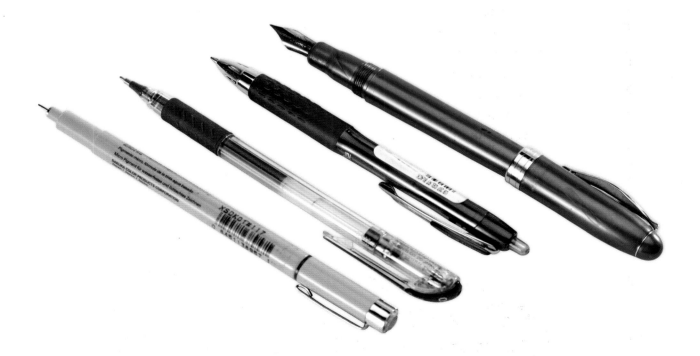

Filling a Fountain Pen

Waterproof inks come in a variety of shades. I prefer black or sepia.

Materials

fountain pen
paper towels
piston converter
waterproof ink

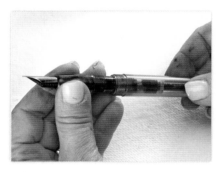

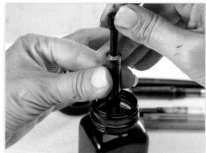

1 Unscrew the pen top from the body.

2 Place the pen vertically in the ink with the nib submerged. Turn the piston or pull the plunger until ink fills the reservoir in the pen. Wipe off the pen nib and screw the body back on the pen.

Piston Converter

A piston converter is a removable ink bladder you can buy for a pen that comes with a cartridge. It is placed in the body of the pen and then filled with waterproof ink. Each brand of pen has its own brand of piston converter.

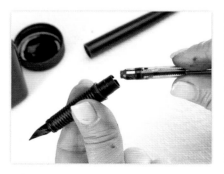

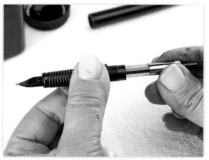

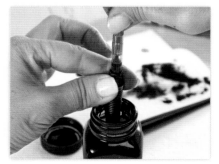

1 Remove the non-waterproof ink cartridge. Replace the cartridge with a piston converter by snapping it in the place where the cartridge was.

2 Dip the pen in a bottle of ink and turn the plunger to fill it.

Unclogging a Fountain Pen

People often become frustrated with fountain pens because when they uncap them to draw, the ink doesn't flow well or sometimes not at all. Here are a few tricks to get the ink flowing.

Materials

- fountain pen
- paper
- paper towels
- spray bottle with water
- water container with clean water

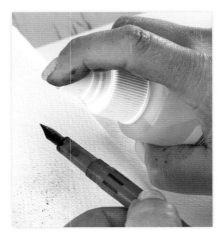 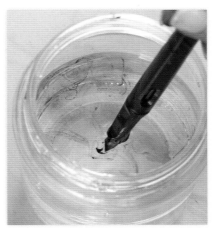 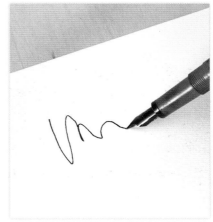

1 Use a spray bottle with water and spritz the end of the pen nib. Or swish the pen in a container of clean water.

2 The water should reactivate the ink and it should begin to flow.

Other Drawing Tools

Experiment with other drawing tools in your paintings and art journals. Here are a few examples to get you started:

Pencils: Both mechanical and wood pencils are available with different types of lead. I prefer to use an HB or 2B lead as it is softer and easier to erase.

There are also several different kinds of watercolor pencils that come in a variety of colors.

Crayons: There are many different types of water-soluble crayons and pastels on the market that make a nice addition to watercolor work. If a crayon is broken off, use the large size of a brass pencil sharpener to sharpen it to a point.

Markers: Water-soluble markers or watercolor markers with a brush tip are also available.

Journals and Watercolor Paper

Journals can be store bought or handmade with watercolor paper. They come hardbound as well as with a spiral binding in a variety of shapes and sizes. The most important thing to pay attention to is the type and weight of the watercolor paper the journals contain. I prefer 140-lb. (300gsm) paper because it holds up well to water and paint.

Watercolor paper comes in different weights, textures, colors and shapes. Once again, this is about personal preference, so I suggest buying a few small sheets of different kinds and test-driving them before you make a large purchase.

Weight

90-lb. (185gsm) is very lightweight paper that will buckle with water.

140-lb. (300gsm) is average-weight paper that will buckle slightly but will flatten out.

300-lb. (640gsm) is heavyweight watercolor paper that will not buckle and does not need to be stretched.

Texture

Hot-press has a smooth surface or little tooth.
Cold-press has a textured surface.
Rough has a highly textured surface.

Colors

Natural is a soft, warm white.
Bright is a cool, bright white.

Shapes

Individual pages are sold as full sheets of 30" × 22" (76 cm × 56cm) and half sheets of 15" × 22" (38cm × 56cm).

Tablets are glued together on one side like a notebook.

Blocks are glued 95 percent around to avoid buckling. The pages are torn off when they are dry.

Brushes

Investing in high-quality watercolor brushes is key. It can make all the difference in how you feel about watercolor and the results you will get. Brushes come in natural hair, which is usually sable or squirrel, and synthetic bristles. They also come in a variety of shapes and sizes from 000 to 24.

I suggest sable brushes above all. They are costly but well worth the investment and will last you a lifetime if you take care of them. The reason a natural-hair brush is so superior is that the hair comes to a fine point and holds a great deal of water and paint in its belly. Therefore you can use your brush a long time before having to reload it with paint. Synthetic bristles have a "spring" to them and do not hold great amounts of water and paint. They also do not have a precise point. That being said, there are some synthetic squirrel hair brushes and combination hair brushes on the market that do offer a good alternative.

The bristles of round brushes are arranged in a circle with a pointed tip.

A flat brush has bristles arranged in a flat line and ranges in size from ½" (12mm) to 2" (51mm).

A dagger is an angled flat brush.

A cat's tongue is a combination of a flat and round brush with a pointed tip.

A mottler is a wide, flat wash brush.

Script brushes have thin, long, round bristles for making lone thin lines.

Sable hair paintbrush

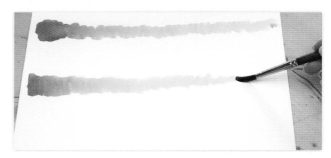

Synthetic squirrel hair paintbrush

Synthetic bristle paintbrush

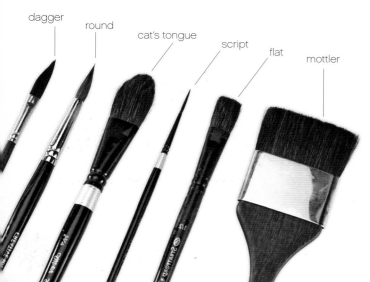

dagger round cat's tongue script flat mottler

Watercolor Paintbrush Basics

There is a gentleness to watercolor that translates to how you hold a brush. I like to remind people that it is called *water*color, which means the majority of the painting mixture is water with a bit of color. When holding a brush, hold it lightly in your hand toward the middle or end of the brush. Guide the watercolor along the surface of the paper with the bristles nearly horizontal. It is important to remember that you are not using up-and-down strokes as you would when painting a house or fence. Keep in mind that there will be times that call for a different hand position for unique strokes.

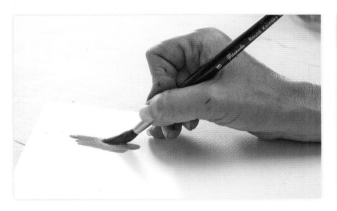
Incorrect way to hold a watercolor brush: vertical like a pencil.

Correct way to hold a watercolor brush: horizontal toward the center of the handle.

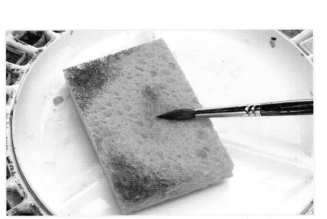
To clean a brush, rinse the brush in water. Then pull and twist the bristles against a damp sponge to bring the bristles to a point.

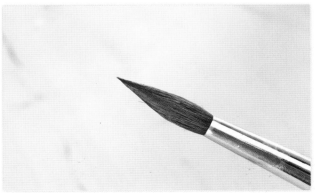
A nice, sharp point! Do not pull the brush straight toward you or you'll get a flat brush.

Watercolor Paint

Juicy, saturated, luscious, transparent, granular, vibrant, subtle, fickle watercolor paint! When it comes to watercolor paint, investing in high quality is very important to give you the results you want.

Less expensive brands are filled with a lot of binders and little pigment, resulting in a chalky finish. Paints come in student and artist grade. If you are just starting out, I recommend purchasing a high-quality artist grade set of half pans. These will last you a long time.

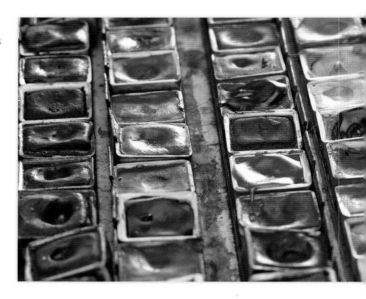

Pan Paint

Watercolors come in full pans and half pans. These are paints that are already dried and in a block that are easily reconstituted with water. I prefer half pans because I like being able to fit a wider variety of colors into my palette.

Tube Paint

These paints come in a variety of different-sized tubes including 5ml, 15ml and 37ml. After filling empty half pans with tube paint, I allow them to harden before placing the pans in a palette. In this way I extend the life of my paint. Once paint has hardened in a pan, it lasts for years. If paint is left in a tube, however, it has a shorter shelf life and will dry and separate.

Visit CreateMixedMedia.com/no-excuses-watercolor for downloadable bonus material.

Color

I love the huge variety of colors that can be found in watercolor paint. There are deeply saturated, almost opaque colors as well as grainy translucent ones. I favor the natural pigment colors that pool into different tones and textures.

Translucency

One of the beauties of watercolor is its translucent quality. The very fact that you can see through it to what lies beyond creates a kind of mystery to its magic. The majority of colors are transparent; however, colors range from transparent to semitransparent to opaque.

Granulation

The simplest way to explain granulation is that flecks of pigment separate from the rest of the paint when dry, creating a sandy, textured appearance. This happens most of the time when denser, inorganic pigments contain metals, which then drop away from the binder and water and settle into the pores of the watercolor paper.

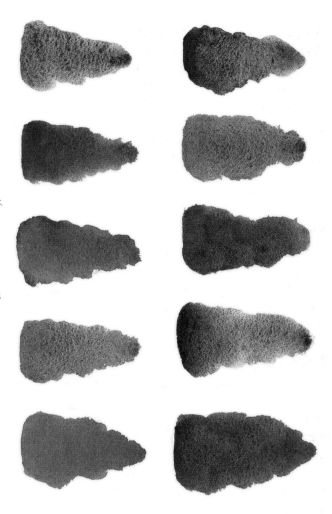

Granulating Colors

Row 1 :
Hematite
Green Apatite
Moonglow
Zoisite Genuine
Cascade Green

Row 2 :
Bloodstone Genuine
Sodalite Genuine
Purpurite Genuine
Lunar Black
Piemontite Geniune

Color Charts

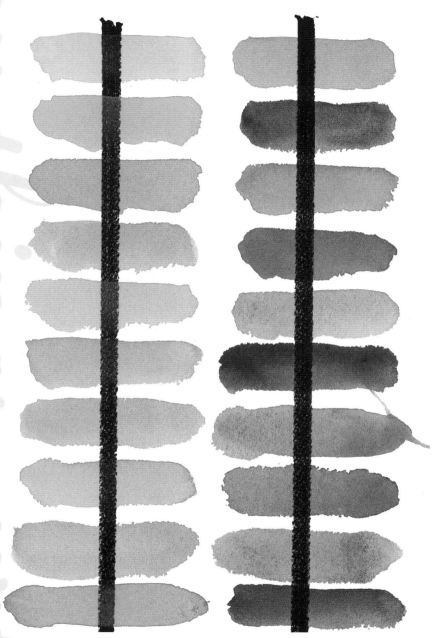

Color Chart Key

Paint Manufacturers:
DS—Daniel Smith
HWC—Holbein Artists' Watercolor
SEN—Sennelier l'Aquarelle
OH—Old Holland
CJ—Cheap Joe's

Transparency:
T—transparent
ST—semitransparent
O—opaque

Granulation:
G—granulating
NG—non-granulating

Color Chart 1

Left Column
1. Lemon Yellow DS T G
2. Cadmium Yellow Hue DS ST NG
3. New Gamboge DS T NG
4. Nickel Azo Yellow DS T NG
5. Naples Yellow DS ST NG
6. Naples Yellow Deep DS ST NG
7. Transparent Yellow Oxide DS T G
8. Yellow Ochre DS T G
9. Burgundy Yellow Ochre DS T G
10. Permanent Yellow Deep HWC T NG

Right Column
1. Indian Yellow DS T NG
2. Italian Burnt Sienna DS ST G
3. Quinacridone Gold DS T G
4. Quinacridone Gold Deep DS T G
5. Burnt Tiger's Eye Genuine DS T G
6. Burnt Sienna DS ST G
7. Burgundy Red Ochre DS ST G
8. Sepia DS ST G
9. Van Dyke Brown DS ST G
10. Caput Mortum SEN ST NG

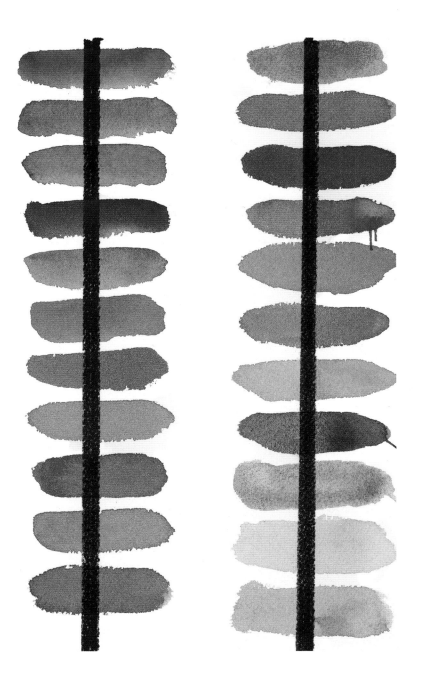

Color Chart 2

Left Column
1. Quinacridone Sienna CJ T G
2. Quinacridone Burnt Orange CJ T G
3. Quinacridone Burnt Scarlet CJ T G
4. English Red Earth DS O G
5. Lunar Red Rock DS ST G
6. Brilliant Orange HWC ST NG
7. Pyrrole Orange DS ST NG
8. Cadmium Red Light DS O NG
9. Bright Red SEN ST NG
10. Scarlet Lacquer SEN ST NG
11. Deep Scarlet DS ST NG

Right Column
1. Mayan Red DS T G
2. Quinacridone Red DS T NG
3. Carmine DS ST NG
4. Quinacridone Rose DS T NG
5. Brown Madder DS ST NG
6. Raw Umber Violet DS ST G
7. Opera Pink DS T G
8. Piemontite Geniune DS ST G
9. Naphthamide Maroon DS ST NG
10. Rhodonite Genuine DS T NG
11. Rose Madder Genuine DS T G

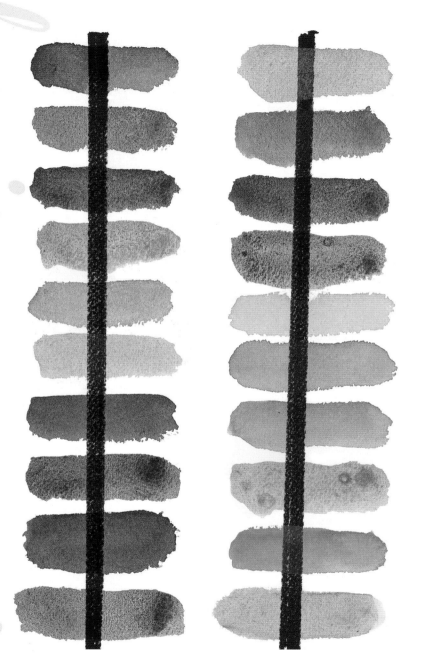

Color Chart 3

Left Column
1. Mineral Violet HWC T NG
2. Amethyst Genuine DS ST G
3. Purpurite Genuine DS ST G
4. Cobalt Violet Deep DS T G
5. Bright Violet HWC T NG
6. Iridescent Sapphire DS O NG
7. Shadow Violet DS T G
8. Bloodstone Genuine DS T G
9. Moonglow DS T G
10 Sodalite Genuine DS ST G

Right Column
1. Sugilite Genuine DS T G
2. Kyanite Genuine DS T G
3. Zoisite Genuine DS ST G
4. Hematite Genuine DS ST G
5. Violet Grey OH O NG
6. Getz Grey CJ O NG
7. Light Gray HWC ST G
8. Cerulean Blue DS ST G
9. Horizon Blue HWC O NG
10. Lapis Lazuli Genuine DS T G

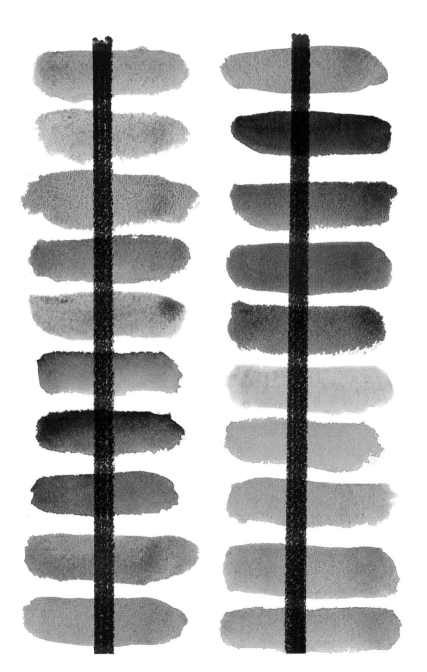

Color Chart 4

Left Column
1. Vivianite DS T G
2. Lunar Blue DS ST G
3. Blue Apatite Genuine DS T G
4. Ultramarine Blue DS T G
5. Mayan Blue Genuine DS T G
6. Phthalo Blue HWC T G
7. Prussian Blue HWC T G
8. Phthalo Turquoise DS T NG
9. Sleeping Beauty Turquoise
 Genuine DS ST G
10. Kingman Green Turquoise
 Genuine DS T G

Right Column
1. Amazonite Genuine DS T NG
2. Phthalo Green DS T NG
3. Perylene Green DS ST NG
4. Cascade Green DS ST G
5. Jadeite Genuine DS ST G
6. Bohemian Green Earth DS T NG
7. Green Gold DS T NG
8. Terre Verte DS T G
9. Rare Green Earth DS T G
10. Deep Sap Green DS T NG

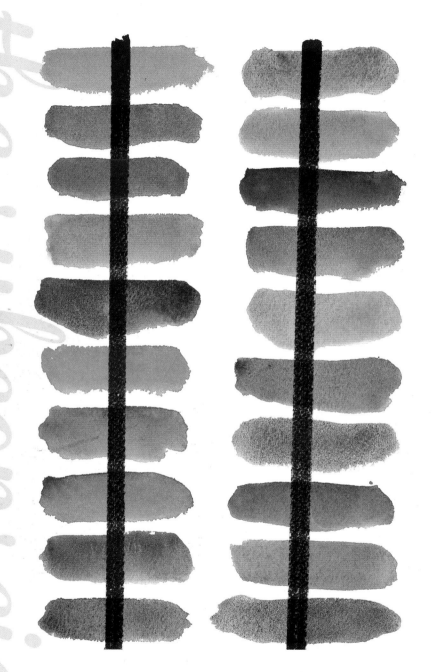

Color Chart 5

Left Column
1. Phthalo Yellow Green DS ST NG
2. Undersea Green DS ST G
3. Rainforest CJ O NG
4. Serpentine Genuine DS ST G
5. Green Apatite Genuine DS ST G
6. Bamboo Green HWC O NG
7. Viridian DS ST G
8. Hooker's Green DS ST NG
9. Chromium Green Oxide DS O G
10. Payne's Gray DS ST G

Right Column
1. Tiger's Eye Genuine DS T G
2. Yavapai Genuine DS T G
3. Raw Umber DS ST G
4. Burnt Umber DS T G
5. Sicklerite Genuine DS T G
6. Mummy Bauxite DS ST G
7. Lunar Earth DS T G
8. Ivory Black DS ST G
9. Black Tourmaline Genuine DS T G
10. Lunar Black DS T G

Palettes

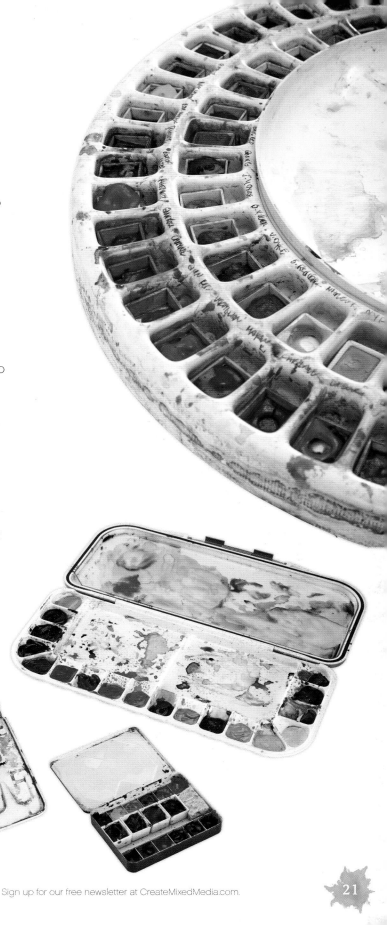

Enamel

Enamel palettes are generally black on the outside and white enamel on the inside. They are divided into half-pan or full-pan sections with mixing wells to the side. They are durable and mostly stain resistant and can be cleaned easily. They are my go-to choice for travel as they come in a variety of compact sizes and individual pans can be inserted and removed easily.

Porcelain

Ceramic glazed porcelain palettes are great for studio work as they are heavy, stain resistant, easy to clean and help keep paint moist. Paint is squeezed directly into the wells and can be reconstituted with water easily.

Plastic

Plastic palettes are inexpensive and light for travel. The downside is that they stain and are hard to clean. When mixing colors the paint tends to bead up because of the plastic surface, making it difficult to see the true shade.

Miscellaneous Materials

Transfer Paper

Graphite transfer paper is one way to get a clean sketch onto watercolor paper. Simply lay down the graphite paper under your sketch or image and trace the top lines. A clean, soft sketch will now be on your paper. This is a great way to start for those who do not have the confidence in their drawing skills when they first venture out into watercolor.

Sponges

Sponges are probably my most valuable watercolor tool. I could not live without them. I buy inexpensive kitchen sponges by the dozens. They are always present by my palette for wiping off the water from my brush. They can also be cut easily with scissors to fit in a travel palette and are quickly reconstituted with a spray of water.

Liquid Frisket or Masque

Frisket is a wonderful tool to use in watercolors for saving white areas or for blocking out areas in order to paint over them easily. It comes in both squeeze bottles with needle-fine points as well as jars to be applied like paint with a dedicated brush or tool.

Lightbox

Lightboxes come in a variety of different sizes and shapes. They are a great resource for transferring your sketches and images onto watercolor paper.

Spray Bottle

I always have a spray bottle filled with clean water nearby to spray down my dry watercolor palette and for adding drips and texture to my work.

Small Hair Dryer

A small hair dryer comes in handy for drying layers of paint to speed up the process.

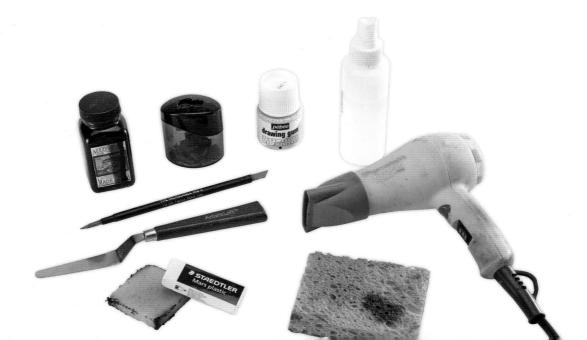

Using Liquid Frisket

The most important things to remember when using frisket is to let it dry completely before painting over it and to then let the paint completely dry before removing the frisket. Frisket should be applied with a tip, tool or cheap brush and the instrument should be cleaned immediately after use. Never use your watercolor brushes to apply frisket! It will ruin them.

Materials

liquid frisket
liquid frisket brush
water
watercolor paint
watercolor paper

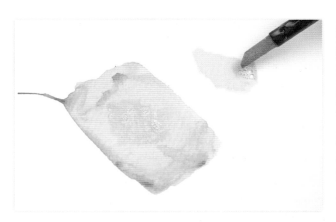

1 To test your liquid frisket, apply a small amount of the frisket with a frisket brush over an area of paint, and over a white place on your paper.

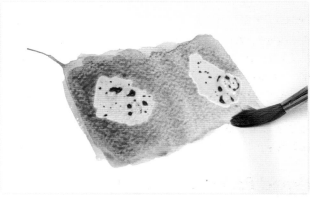

2 Allow the frisket to dry completely, then paint over both test areas with a darker color of watercolor paint.

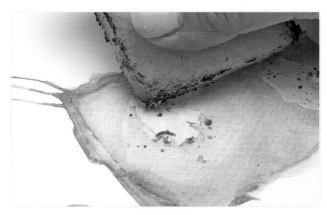

3 When the paint is completely dry, remove the frisket by rubbing it off with a rubber cement pickup.

4 The area to the left retained the light pink shade under the purple. The area to the right retained the white of the paper.

Studio Setup

Everyone wants a large space filled with lots of light, high ceilings and good ventilation, but the reality is that few of us have our dream studio. This is no excuse, however, for not painting! The great thing about watercolor painting is that you can do it practically any-where—even in the smallest spaces. That being said, let's take a look into a few different studio setups.

My Personal Studio

My studio is located in a spare room in my home. I installed a linoleum tile floor that is forgiving, easy to clean and easy to roll wheeled carts and chairs. Speaking of wheels, most of the pieces in my studio have them so I can move things around quickly. This also saves on space as I can roll drawers under tables or pull them out as a stand when needed. My studio has the following:

- a narrow long desk that holds my computer and a rolling unit for my printer and scanner
- a large wooden desk for doing flat work
- a drafting table on wheels for doing watercolors and to use as another surface for drawing and painting
- a rolling stool and chair to move around between stations easily
- rolling drawers and carts to store materials and to use as movable tables

- bookshelves
- magnified drafting lights that provide a great source of light and can be moved around; the magnifier is extremely helpful for detailed work
- a variety of containers for holding brushes, pens and materials

Creating Your Own Studio Space

A "studio" can be created anywhere—a spare room, garage, shed, greenhouse or a desk in the corner of a room. Basically you need what Virginia Woolf refers to as "a room of one's own"—a place where you can find peace, comfort and focus. I think it is essential to create a space that you love to be in. Surround yourself with colors, scents and sounds that fill you up.

You need a few basic things to have a working studio:

- table or desk
- chair or stool
- good lighting
- storage
- book shelf

Nice additions:

- computer
- scanner
- printer
- lightbox

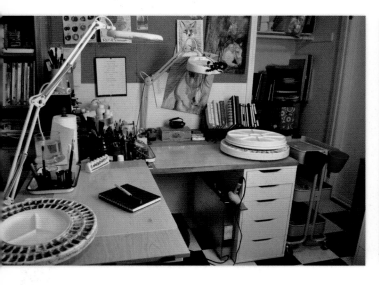

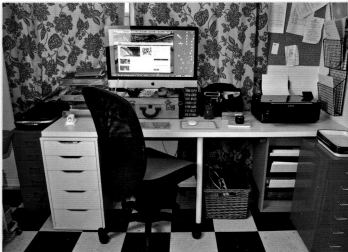

Travel Kit

While having a designated studio space is wonderful, it is not a necessity because a small travel kit can take you just about anywhere. Include the following in your travel kit:

- bag
- pens, pencil, eraser
- one or two travel brushes
- travel palette
- water container
- sponge
- journal

When I travel I bring my small travel kit, which can fit in a purse or backpack. I have painted and sketched in my journal on planes, on a boat, in the car, at the beach, sitting at the bottom of the ski slopes at a table watching my boys ski, on the deck by the pool, in bed, at the airport and in the car while I wait for my boys at practice. You can do this anywhere! All you need is a small flat surface and some water and you are good to go.

25

Getting to Know
Your Paints

Now that we have some knowledge about the different materials you will need, it's time to get to the good stuff . . . painting!

In this chapter you'll create a palette that works best for you and try some basic painting exercises to get to know the properties of your paints.

Creating a Paint Palette

The first thing to do when creating a palette is to decide what purpose it will serve. In many cases you may decide to have more than one kind. Below is a chart that may help to guide you.

Choosing the style of palette will help you determine if you are going to use prepackaged half pans tube paint, or fill your own pans. Limited brands are available in prepackaged pans whereas all brands are available in tubes.

In addition to an extra-small travel set with only essential colors, I have a set of forty-eight artist-quality half pans in an enamel case that is my old faithful workhorse on the go. In my studio I have a large, spinning studio palette with half pans that I continue to fill from my tubes. I am not a traditional color mixer and love to have a plethora of colors readily available, so this method works well for me.

	Travel	Studio	Half Pans	Tube
Plastic	X	X		X
Enamel	X	X	X	X
Porcelain		X		X

Filling a Half Pan

Materials

empty half pan
permanent marker
tube paint

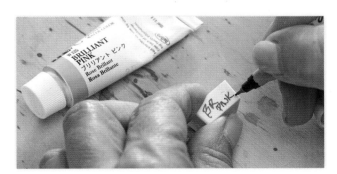

1 Label your pan with the name and maker of the paint with a permanent marker.

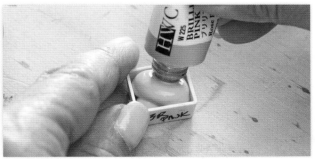

2 Squeeze paint into the pan to fill.
Allow the paint to dry completely before putting it into a travel palette. It can take up to a week in some humid climates for the paint to dry all the way through.

Creating a Color Chart

It is important when you are starting out with a new palette to create a color chart to use as a reference when painting. It is often difficult to discern the color of the paint once it has dried.

Materials

paintbrush
permanent marker
ruler
travel palette with paint
watercolor paper
waterproof pen

1 Determine the size of paper you will need for your chart. I do this by measuring the inside lid of my palette and tearing down the paper so it will fit inside easily. Tear down the paper along the marked lines using a metal ruler.

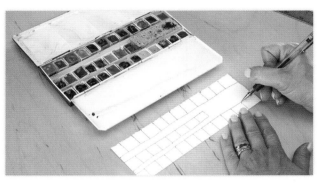

2 Using a pen with waterproof ink, draw a grid that represents the inside of your palette.

Determine the number of colors you need or can fit in your palette, then lay out the tubes of paint or pans in the order you want them. I usually arrange them according to the color wheel. You only need to do this if you are creating your own palette.

3 Label each pan on its side with permanent marker, then label each square on your chart according to your layout. Some half pans come individually wrapped with the name on the label and some have them already printed on the sides.

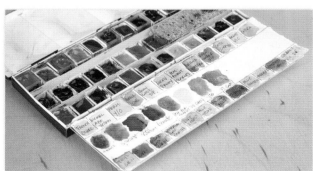

4 Paint a color swatch in each corresponding box and place the color chart in the lid of the palette.

Playing with Paint

You are now set up and ready to start exploring! Try these basic techniques in watercolor to set the stage for later work.

Materials

paintbrush
watercolor paints
watercolor paper
water

BLEED

Lay down one color of paint and lay down another color of paint right next to it. The paints will bleed together, creating an interesting effect. Some pigments bleed more easily than others.

BLEND

Lay down one color of paint and on one side lay down another color of paint, leaving a small space between the two. Use clean, clear water on a damp brush to blend the two sides together, creating a soft edge.

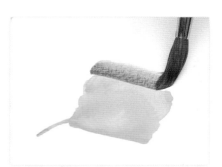

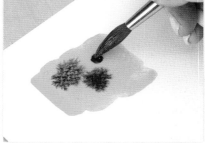

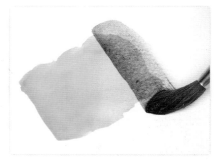

HARD EDGE

Lay down one color of paint and allow it to dry completely. Lay down another color touching its side to create a hard, crisp edge.

WET-ON-WET

Lay down one color of paint and while the paint is still wet, drop another color on the surface to create a bloom effect.

GLAZING

Lay down a color, such as yellow, and let it dry completely. Then overlap part of the area with another color, such as blue. The area of overlap will now appear greenish.

Play Exercise

This exercise is a fun way to explore your paints and the way they work with one another. Use a page in your watercolor journal or a blank piece of watercolor paper.

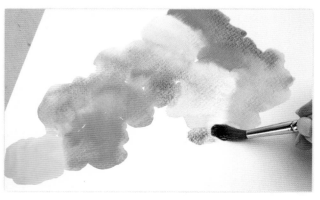

Materials

paintbrush
water
watercolor paper
watercolor paints

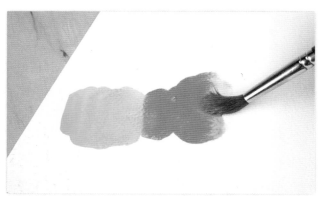

1 Lay down a swatch of color. Then choose another color and lay it down next to the first.

2 Keep doing this with alternating colors in a patchwork fashion. In this way, you will learn what colors you like beside one another and the way they interact with one another.

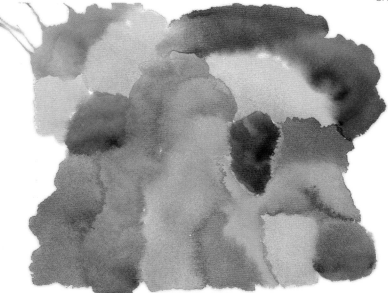

Bleed Exercise

This exercise is a great way to learn what colors bleed and blend well together. I suggest keeping this chart as a reference for future work.

Materials

paintbrush
water
watercolor paper
watercolor paints

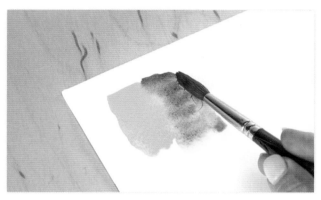

1 Lay down a color swatch on the left column of the paper and while it is still damp, lay another color beside it in the right column.

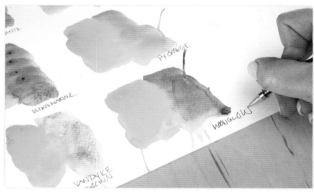

2 Lay down the same color in each left column and continue the process by laying down alternate colors in the right column. Label each color as you go.

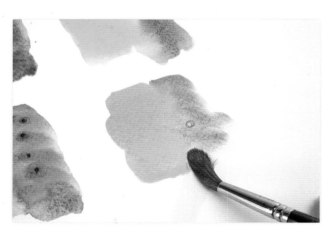

3 In this way you will see what colors work well with one another. I like to put a star by the color combinations I like and make a note of where they might work in the future, e.g., leaves, trees, etc.

Background: Wash

There are many ways to create simple yet interesting backgrounds that will make your focus images stand out. I prefer to use artistic license and change up the color backgrounds, choosing one that is often a complementary color to make the image pop.

Materials

paintbrush
water
watercolor paints
watercolor paper

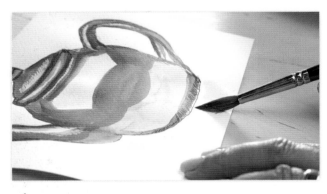

1 Using clean water, wet the paper around the image all the way to the edge of the piece.

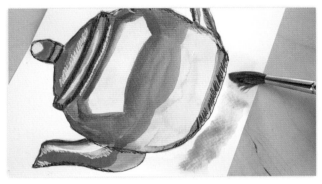

2 Choose your color and brush it on the wet paper.

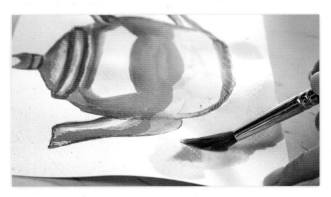

3 Add more of the same color in selected areas to get darker spots.

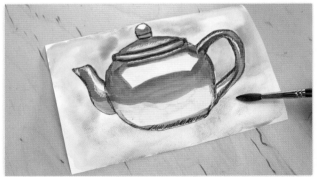

4 Add more water in other areas to create lighter spots, creating a mottled effect.

Add More Color

Choose another color to create a multicolored background. Try a different shade of the same color or another complementary color.

Background: Salt

Salt can be added to a wash while it is wet to create interest and texture in a background.

Materials

paintbrush
salt, table and sea
water
watercolor paper
watercolor paint

1 Lay down a background wash.

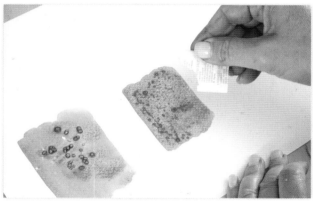

2 Sprinkle salt in several areas while the paint is still wet. Different types of salt create different effects (see below).

Allow the paint to dry completely, then gently brush off the salt.

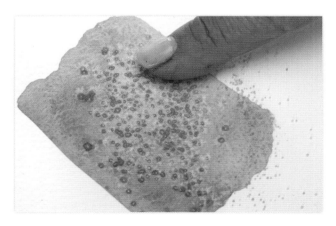

TABLE SALT

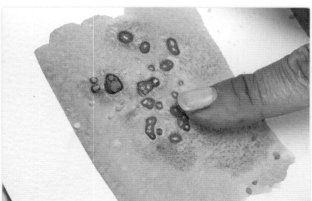

SEA SALT

Drawing for Successful Painting

In order to be successful with watercolor you

first have to be comfortable with drawing. Don't shut the book! Take a moment, breathe! Many people are so afraid their drawing skills are not good enough or that they can't draw at all and this fear stops them in their tracks. Not to worry! In

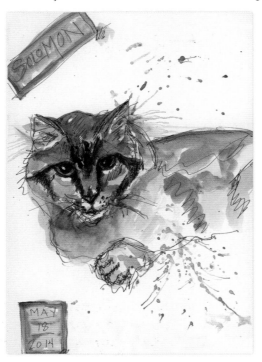

this chapter you will find a variety of techniques that will make even the biggest scaredy cat feel confident. But first, I will let you in on a secret to drawing . . . DRAW! The more you do it the better you'll get. It's muscle memory. Remember the first time you rode a bike? Terrifying! The second time it got a little better and then before you knew it, riding was a breeze and you peddled away without even thinking about it. Drawing is the same. Sure there are growing pains, but stick with it. I promise you that if you draw something, even a little sketch, every day for a month you will greatly improve. So in this chapter try all of the different styles and stick with the one that you gravitate to the most.

Tracing

Tracing images is a great way to get started. You can use transfer paper or a lightbox depending on the resources you have available.

Materials

lightbox
pencil
reference image
transfer paper
watercolor paper

Transfer Paper

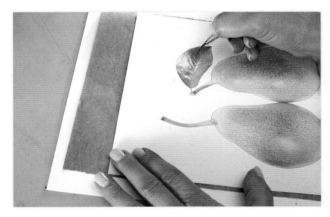

1 Layer your papers: watercolor paper on the bottom, then a sheet of transfer paper with the graphite down on the watercolor paper. Place the reference image on top. Trace the image on itself using a pencil.

2 Lift up the image and the transfer paper to reveal your traced image.

Lightbox

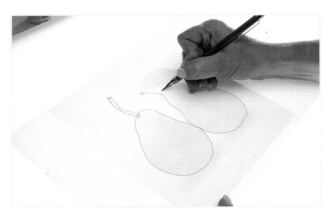

1 Turn on your lightbox. Layer your image on the bottom and watercolor paper on top. Trace the outline of the images as detailed as you can see or you want.

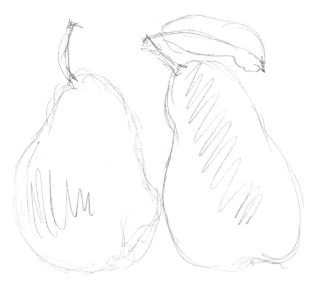

GESTURE DRAWING

A gesture drawing is a quick one-minute sketch that gives you the feel for an object. It does not contain details and is done with a loose, quick, flowing stroke.

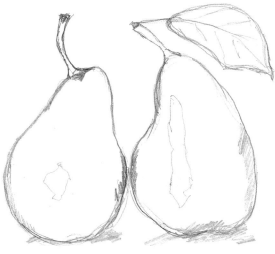

PENCIL SKETCH

A pencil sketch is a quick drawing of an object that contains some details and shading. I like to explain the act of sketching as feeling your way around the drawing with quick, short strokes of the pencil.

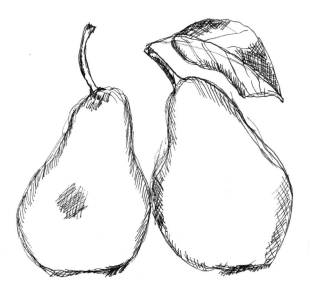

INK SKETCH

Like the pencil sketch, an ink sketch has the same movement and feel. I often add crosshatching to my ink sketches to add shading and detail.

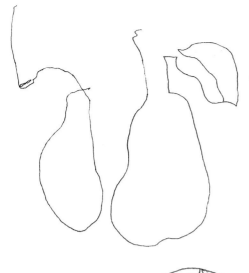

BLIND CONTOUR

Everyone hates to do these drawings because it means giving up control over what you think you see versus what you actually see. The exercise, however, is wonderful for improving your seeing and drawing skills. The key is to not look at your hand or paper but at the contours of the object. Your eye and your pen should be moving around the object very slowly. Don't expect for it to look like very much; that's not the point. The point is to draw what you see rather than what you think something should look like.

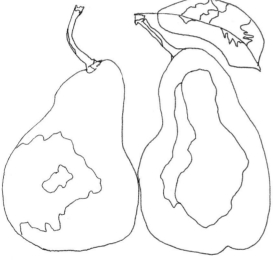

INK CONTOUR

In this style of drawing you are using the same concept of the blind contour by focusing on the outer contours of an object and drawing what you see while keeping a peripheral eye on your paper. Once again, go slow and take your time. This drawing should be made up of long, continuous lines. You can also draw the shapes of the shadows and highlights on the object to add dimension.

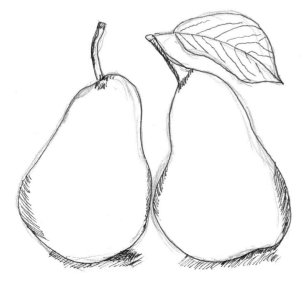

INK AND PENCIL SKETCH

First create a pencil sketch. Then ink the drawing over top once you have the size and shape you want to achieve underneath. You can then erase the pencil lines and have a finished line drawing.

Fast and Fun Exercise

A quick and easy way to get started with sketching and watercolor is to do quick ink sketches and then add a splash or two of watercolor. It is like dipping your toe in the water before plunging in. You get the feel of the water before submerging yourself in its depths.

Materials

hair dryer (optional)
paintbrush
pen with waterproof ink
reference image
water
watercolor paint
watercolor paper

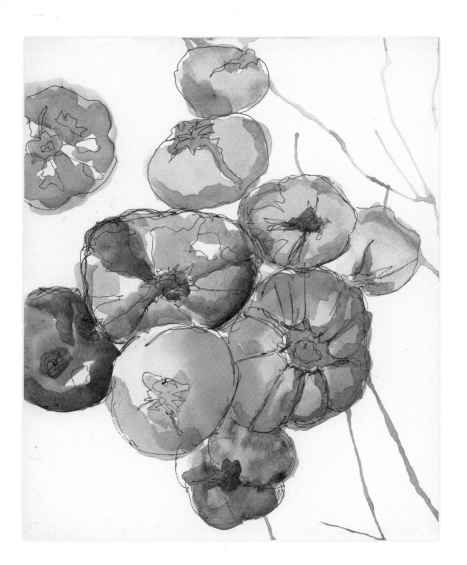

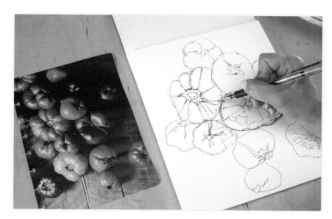

1 Draw a quick sketch of an object using waterproof ink. It is helpful to use a reference photo from a magazine.

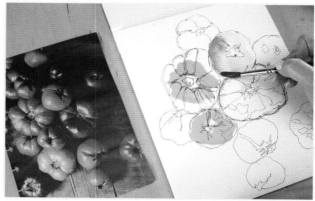

2 Using one to two dominant colors, fill in some of the shapes loosely and quickly. The point is not to fill in each line or shape perfectly, but to add large amounts of color quickly. Do not fill in all of the spaces; leave some of the lightest areas open (paint-free). Allow the painting to dry or help it along with a hair dryer.

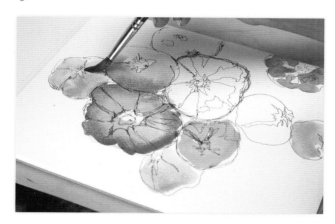

3 Darken the areas around the dominant colors with deeper shades.
　　Add the next darkest color to a few shapes.

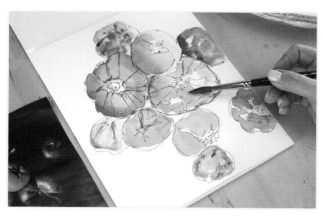

4 Using Shadow Violet or other darker color, add a few strokes of paint to create shadows and add depth to the painting.

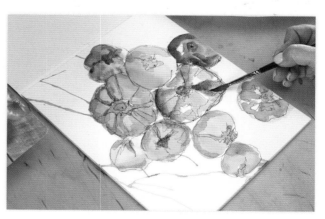

5 Fill in the areas reserved for the darkest color with more Shadow Violet.

Sketch Journal

Use a watercolor journal to work on quick studies and sketches. This is the place where you can have fun, experiment and try things out. Try to use a variety of pencils, pens, watercolor paints, etc. I often tape in magazine clippings and photos to work from.

Materials

paintbrush
pen with waterproof ink
reference image
washi tape
water
watercolor journal or sketchbook
watercolor paint

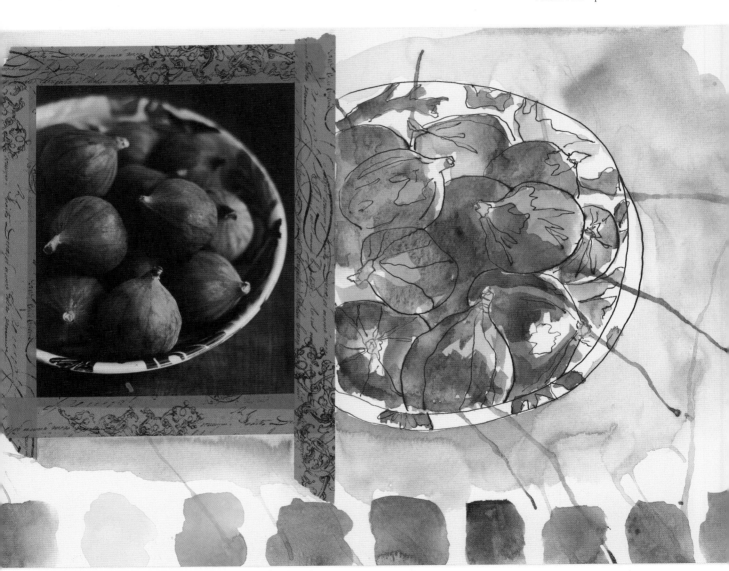

1 Choose an image you want to draw and paint. Tape it to a page in your sketchbook with washi tape.

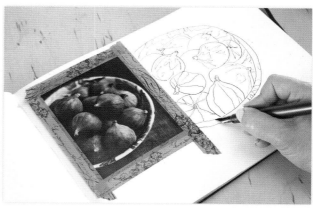

2 Sketch or draw the image on the page.

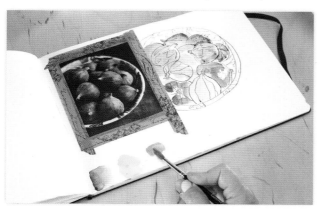

3 Begin with the lightest color and add it to the sketch. Include a swatch of the color along the bottom of the page to create a palette.

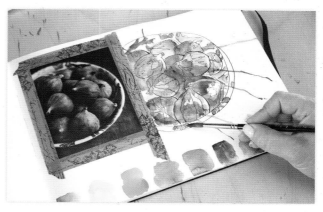

4 Continue with the next lightest color, gradually adding darker colors to your image and palette.

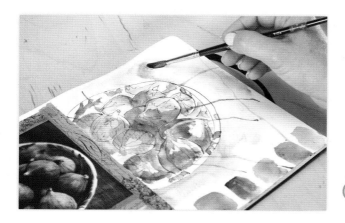

5 After the paint is dry, add a background around the image and magazine clipping to connect the images and create a cohesive picture.

Watercolor Your Way

As I have already stated, I am not a traditional watercolorist but rather someone who uses the spirit and will of watercolor to express the way I see something. I want to capture the essence of an object and convey the

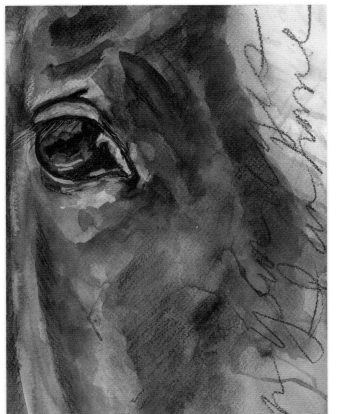

feelings I have about it through the use of color, texture, line and shape. That being said, there still is a step-by-step process that I use when working on a piece.

The Step-by-Step Method

I have chosen to show the same steps but in three different artistic styles. It is important to remember to find your own style and voice. I am giving you some guidelines, but you should let your own voice and choices be heard in your work so it becomes intrinsically yours. For the following three demonstrations, refer to the finished paintings on this page.

Materials

eraser

hair dryer (optional)

liquid frisket and brush (optional)

paintbrushes

pencil

rubber cement pickup

water

watercolor paint

watercolor paper

waterproof pen

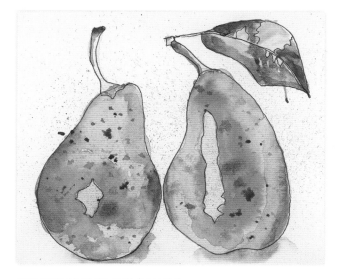

CONTOURED PEARS (PEAR 1)

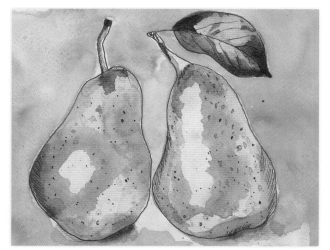

SKETCHED PEARS (PEAR 2)

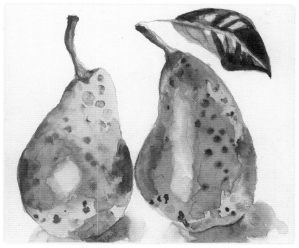

LOOSE PEARS (PEAR 3)

Contoured Pears (Pear 1)

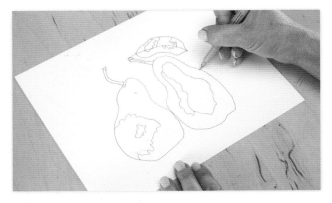

1 Draw a simple contour drawing in waterproof ink. Draw in the highlight as a shape and save the white area.

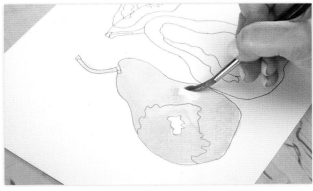

2 Lay down the lightest overall shade of the pear, in this case a pale yellow.

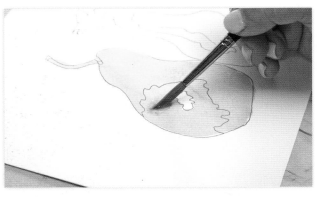

3 While the yellow is still damp, drop in orange on the pear.

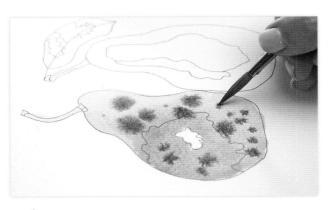

4 Working fast, drop in brown to create specks on the still-wet orange and yellow pear.

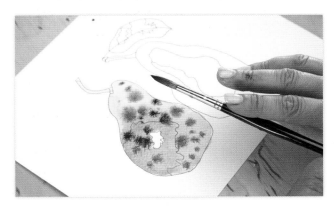

5 The brown specks can also be done by flicking the brush loaded with brown paint for a spattered effect.

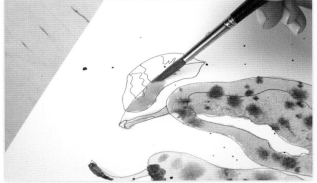

6 Repeat steps 2–5 on the second pear, varying the color as you like.

Paint in a pale green for the leaf except for the white highlighted areas.

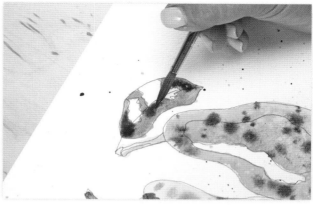

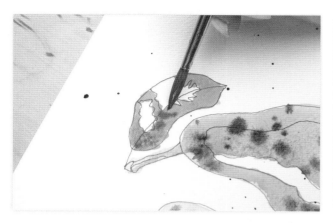

7 Add a medium green onto the leaf to deepen the color.

8 Finally, add a darker green to the leaf.

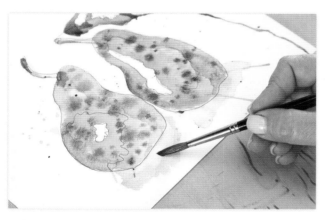

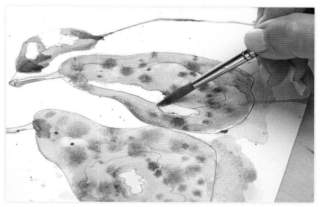

9 Create shadows under the pears using a violet shade.

10 Once the paint is dry, take a clean, damp brush and go over the white areas so a light veil of color softens the shape.

Sketched Pears (Pear 2)

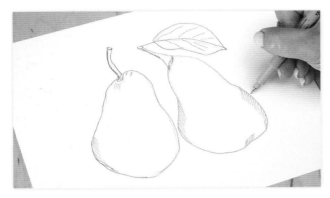

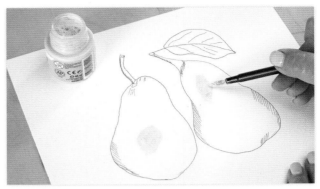

1 Draw a sketch of pears first with pencil, then go over the contour lines with waterproof ink. Add crosshatching to create shadows, and erase the pencil lines.

2 Save the white highlight areas on the pears and leaf by applying liquid frisket. *Do not use your watercolor paintbrush for this.* Allow the frisket to dry completely. Use a hair dryer to speed the drying if needed.

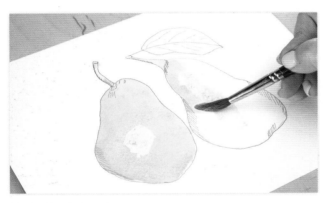

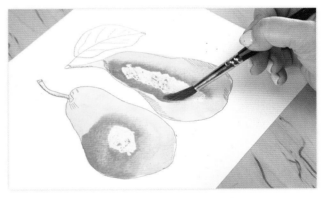

3 Lay down the lightest overall shade of the pear, in this case, a pale yellow.

4 While the yellow paint is still damp, drop in orange on the pear.

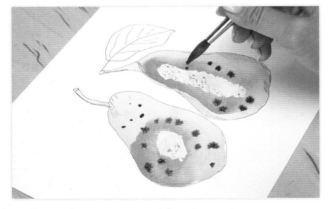

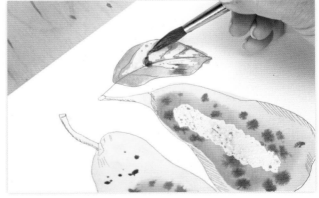

5 While the yellow and orange paints are still damp, drop brown to create specks on each pear. This can also be done by flicking the brush for a spattered effect.

6 Choose a shade of pale green for the leaf and paint it over the whole leaf, including the part covered in frisket. While the green is still damp, add medium green onto the leaf.

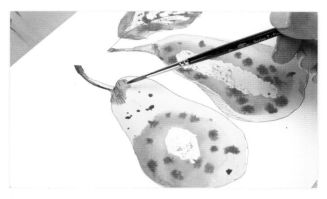

7 Add a darker green to the leaf and add brown to the stem.

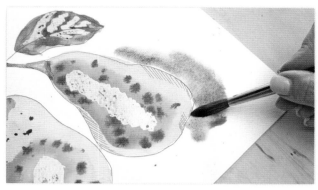

8 Brush a layer of clean, clear water around the figures to dampen the paper. While the paper is still damp, add the background color.

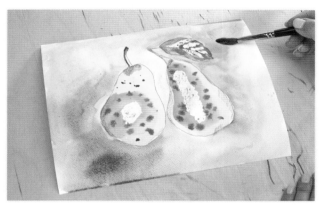

9 Deepen the background by adding another layer of the same color in selected areas.

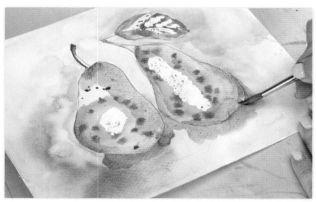

10 Create shadows under the pears using a violet shade.

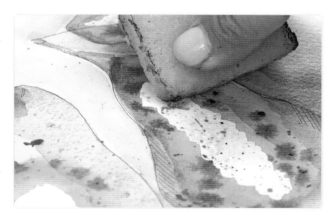

11 Allow the paint to dry completely, then remove the frisket by rubbing it with a rubber cement pickup.

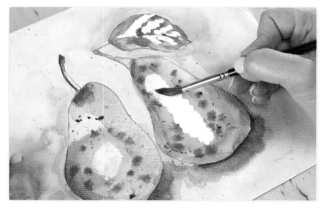

12 Take a clean, damp brush and go over the white areas so a light veil of color softens the highlighted shape.

Loose Pears (Pear 3)

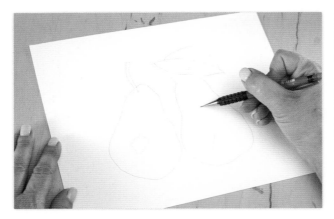

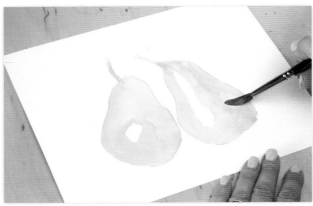

1 Draw a light pencil sketch of the pears. Draw in the highlights as a shape and save the white area.

2 Lay down the lightest overall shade of the pears, in this case a pale yellow.

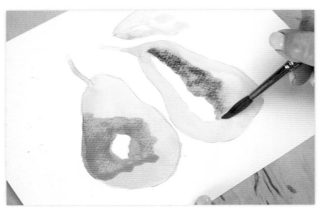

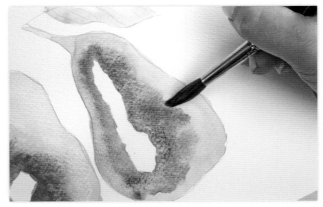

3 While the yellow is still damp, drop in orange on the pears. Begin the leaf by painting it a pale green, taking care to preserve the white highlight.

To make the pear darker, add a deeper red color on top of the orange.

4 Soften the painted edges by loading your brush with clean water and brushing it around the edges of the paint to dissolve them.

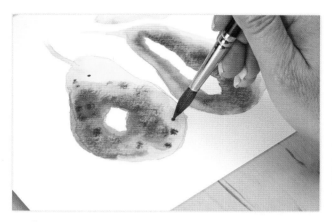

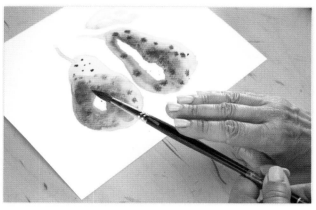

5 While the orange red is still damp, drop in dots of brown to create specks on the pear.

6 This can also be done by gently flicking the brush for a spattered effect.

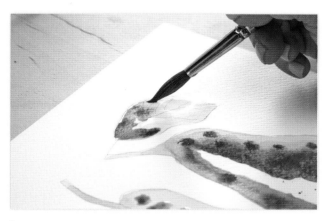

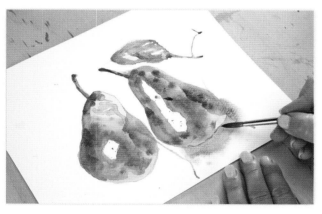

7 Add a medium green onto the leaf, then layer on a darker green to create depth.

8 Use brown on the stems of the pears and around the edges of the pears.
 Create shadows under the pears using a violet shade.

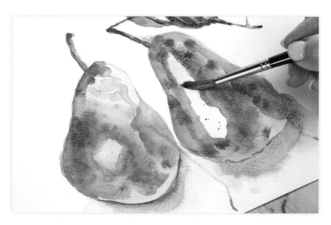

9 Once the paint is dry, take a clean damp brush and go over the white areas so that a light veil of color softens the shape.

Taking Flight: Advanced Project

By now you gave gotten your feet wet and are ready to venture into something a little more daring. I love owls. Their eyes so telling and soulful, and a plethora of different colors and textures in their feathers makes for a stunning subject. In this exercise you will learn how to portray this regal animal in a loose, freeing style while capturing their wild essence. Note: I paint a lot of animals as my subjects and I find the key to a successful piece is capturing the eyes. If you capture the details in their eyes, you show a glimpse into their spirit.

Materials

liquid frisket and brush
paintbrushes
pencil
rubber cement pickup
water
watercolor paint
watercolor paper
watercolor pencils

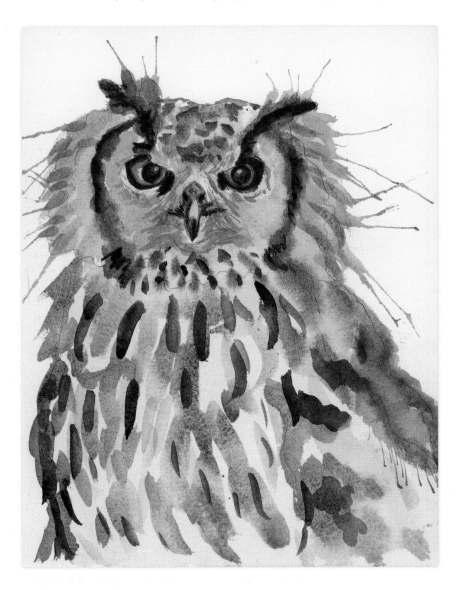

1 Using a reference image, draw the owl in light pencil on a piece of watercolor paper.

2 Save the white highlights of the eyes and beak by applying liquid frisket to these areas. Allow the frisket to dry completely before continuing.

3 Lay down the lightest overall shade of the lightest feather color. I chose a pale gray-brown for my owl.

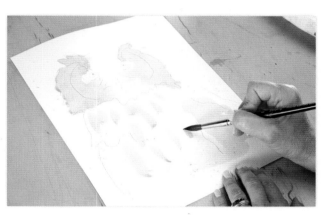

4 While the paint is still damp, lay down the medium-toned feather color in selected spots. Begin to make feather-like strokes on the owl's body.

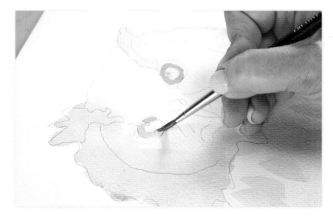

5 Paint the eyes a light yellow.

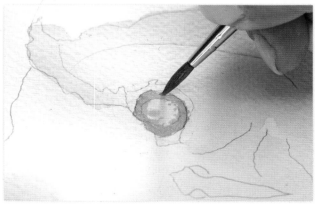

6 Add orange to the outer rims of the eyes while the yellow is still wet.

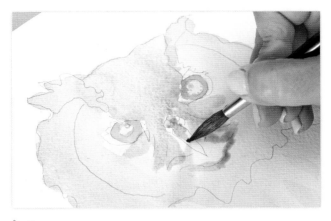

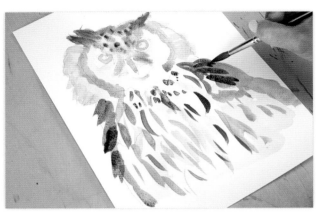

7 Add darker gray tones around the eyes and beak.

8 Working wet-on-wet, drop in dark gray shades to create feathers.

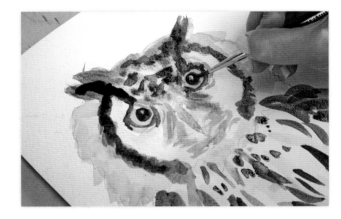

9 Add the darkest shade around the eyes and pupils.

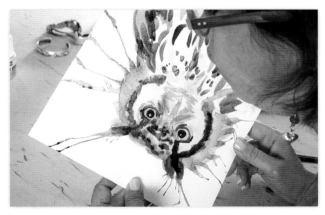

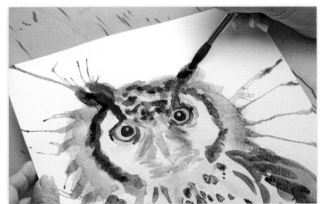

10 Choose a few distinct areas to lay down small puddles of paint. Blow directly on the paint in the direction you want to create movement with a short puff of air very close to the page. If you use a straw, you will get a very different effect than if you blow directly on the paper.

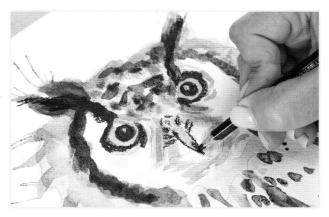

11 Using a water-soluble black colored pencil, add details to the owl around the ears, eyes, beak and anywhere else you'd like.

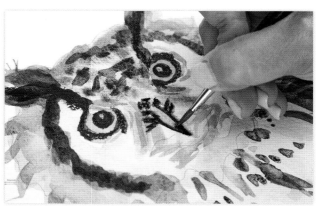

12 Go over the pencil marks with a wet brush to activate the paint in the pencil marks.

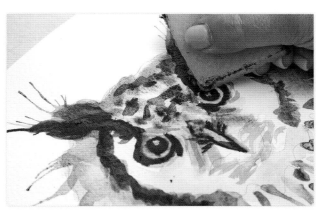

13 When the piece is completely dry, rub off the frisket using a hard cement pickup.

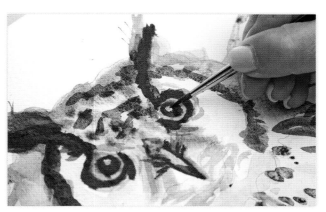

14 Take a clean damp brush and go over the white areas so a light veil of color softens the shape.

Blown Away

One of my signatures is to use blown paint and drips within my work. I love the way they create interest, movement and something extra in a piece.

~RILKE

slowly the west reaches
for clothes of new colors
which
it passes to a row of ancient trees
YOU LOOK, AND SOON these
Two worlds both
have
you
one part
inward
heaven to
one climbs
the earth

the eyes
hold the answers to your soul
I look into those orbs AND FEEL AT HOME
AT PEACE
COMFORT
I AM
SAFETY
GROUNDED AND BALANCED
AND
WHOLE

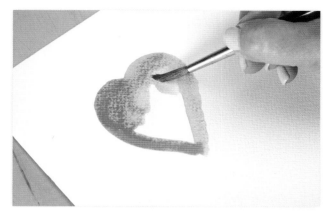

1 Using a light color, such as pink, paint a simple heart.

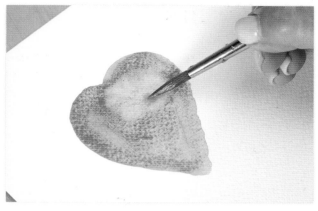

2 Drop in a medium color of paint, orange, while the first layer is still damp.

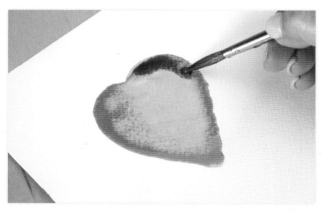

3 Using a darker color, edge the heart while the first layers are still damp so it creates a blooming effect.

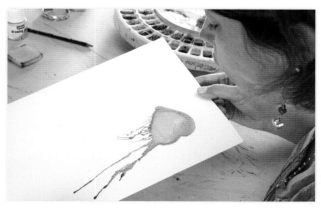

4 Lift the paper and blow air in quick, strong bursts in the direction you want the drips to go.

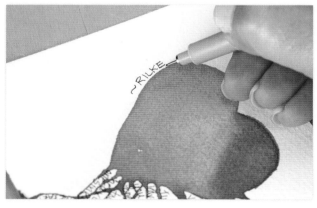

5 Let the paint dry completely. Using a fine-tipped waterproof pen, write out thoughts, quotes or a poem on the drips.

Water-Based Media and Crayons

Water-soluble pens, pencils and crayons make a great addition to a watercolor piece by bringing detail, depth and texture. I like to finish a piece with a pencil or crayon to add details and words.

Materials

paintbrushes
pen or pencil
spray bottle with water
reference images
water
watercolor paper
watercolor pencils, Inktense Pencils or other water-soluble media

Tips to Get Started

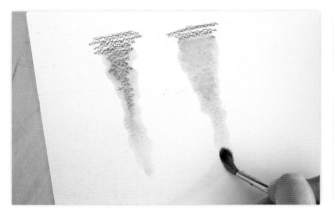

Some pencils leave more of a sketch mark whereas others look just like watercolor paint when water is added.

(Left: Derwent Inktense Pencils, Right: Faber-Castell Albrecht Dürer watercolor pencils)

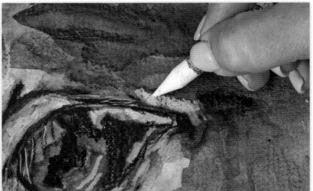

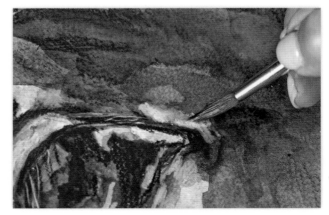

White pencils and crayons are great with or without the use of water to create highlights and emphasis.

Fast and Fun Exercise with Watercolor Pencils

Watercolor pencils can be used straight on the paper in lieu of paint.
This exercise works well on non-watercolor paper because you don't
have to use as much water as with watercolor paints.

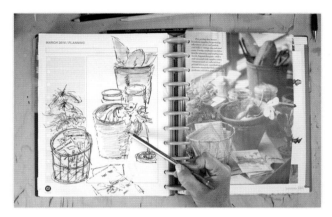

1 Loosely sketch an image on your paper from a reference photo.

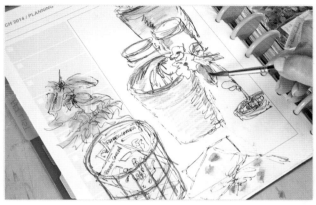

2 Add bits of color to the image using water-soluble colored pencils.

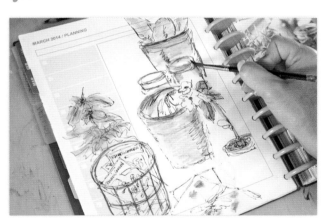

3 After you've added color in all the areas you want, wet a brush and paint the water over the color to activate and blend the paint.

Adding Words and Phrases

Water-soluble crayons and pencils are great for adding words, phrases and depth to your art.

1 Create a watercolor piece and add unique details with pencils or crayons. Using these tools to write out words or phrases on a piece adds that something special a piece might otherwise be missing.

2 Spray the words and other details with water to create a softened effect.

Creating Depth

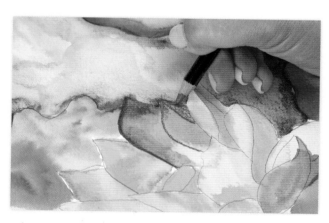

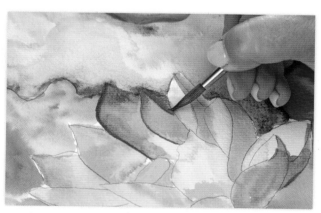

1 Create a watercolor piece and add depth with pencils or crayons. In this piece I chose to lay down edges and details with watercolor pencil.

2 Go over the pencil marks with a damp brush to activate the paint.

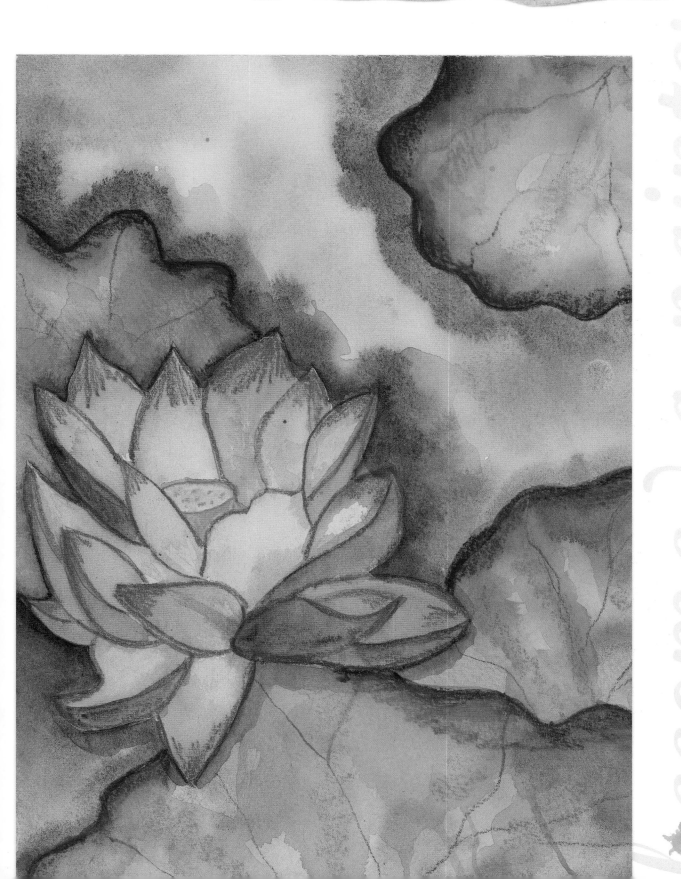

Let's Branch Out!

This exercise puts a bunch of techniques into practice while you create a fun, loose and expressive tree. We learn by doing so this exercise will help cement your skills.

Materials

black water-soluble pencil
hair dryer (optional)
liquid frisket and brush
paintbrush
rubber cement pickup
salt
spray bottle with water
watercolor paint
watercolor paper

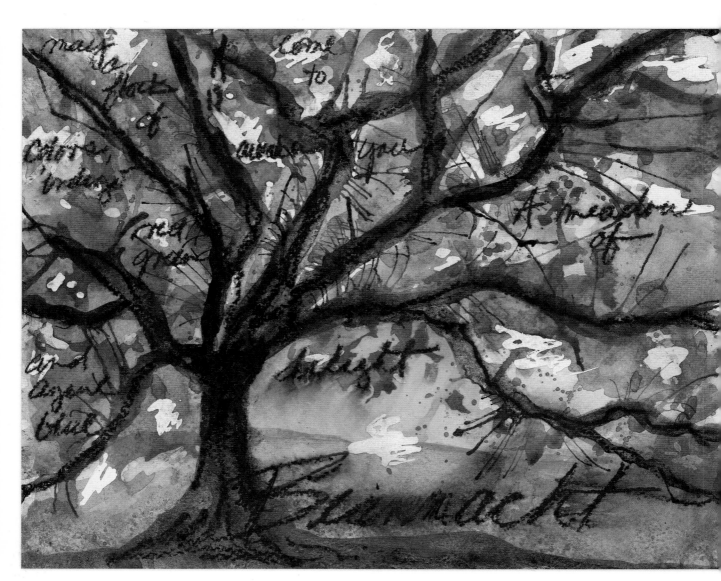

1 Use a dark tone of paint and loosely draw the shape of a tree with branches.

2 Use the blowing technique to create small branches. You can also use a hair dryer to blow the paint lines in different directions (and to prevent dizziness!).

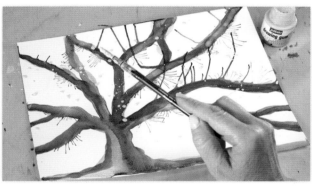

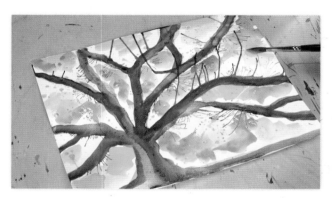

3 Let the paint dry completely.
Spatter liquid frisket throughout the painting to preserve random white areas. Let the frisket dry completely.

4 Add light yellow and green in watery patches between the branches. Use those same colors to add some spatters of paint. Allow the paint to dry.

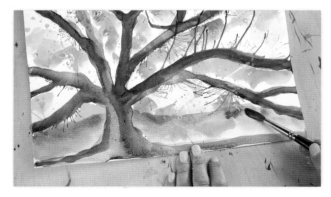

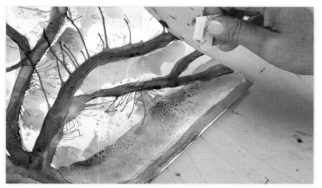

5 Using an ochre color and green, create a ground for the tree.

6 While the ground is still wet, sprinkle it with salt and allow the paint to dry.

Salty Effects

Remember, sea salt and table salt produce different effects with watercolor. Use whichever kind of salt you prefer.

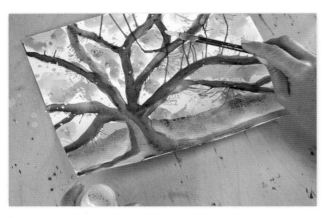

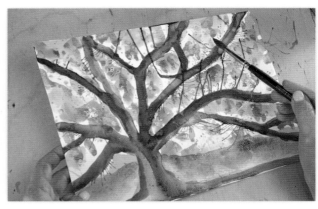

7 Again, spatter liquid frisket throughout the painting, this time to preserve areas of the lighter colors, and allow it to dry completely.

8 Spatter and dab various shades of orange all over the image. Let it dry and then do the same with shades of red and rose, again letting the paint dry between each color.

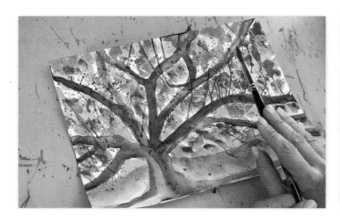

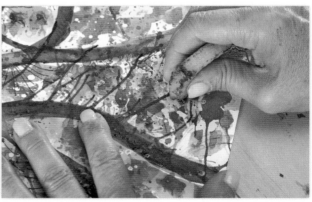

9 Let the paint dry completely. Remove the frisket using a rubber cement pickup to reveal the range of colors in the fall leaves.

10 Using a black water-soluble pencil, enhance the tree branches by adding scribbly lines.

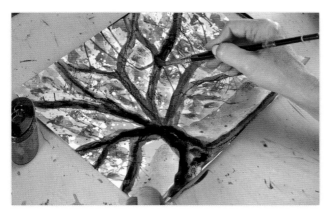

11 Use a wet brush to go over the pencil marks and allow the water to puddle in some areas.

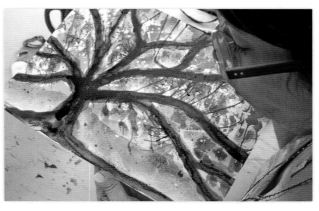

12 Blow puffs of air on the paint puddles to create streaks and drips of paint.

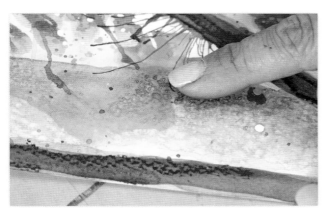

13 Let the paint dry, then wipe off the salt from the ground.

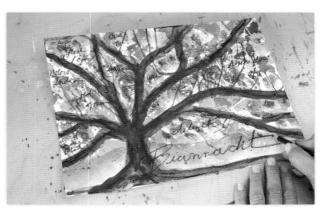

14 Using the same water-soluble pencil, write the words to a poem throughout the branches.

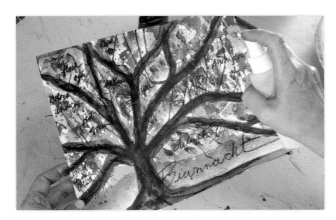

15 Spray the whole piece lightly with water to soften the written words and let it dry completely.

Adding Text

Words are a prominent and driving force in my work. I find that they inspire me and give the work a sense of purpose and passion. I use poems, quotes, phrases and personal journaling. When I don't know where to begin I often just flip through some of my favorite poetry books and keep reading until something speaks to me. The same goes for quotes. I have a collection of favorites that I return to time and time again.

So how do you decide what and where to add words? For me the answer is twofold. Sometimes I am working in a journal where I want to record my memories both visually and with the written word. I most often do this in a travel journal where I want to include the date, place and some specific detail to reflect on when looking back. Secondly, when I am working on an individual piece and come to what I feel is a finishing point, I look at the work and if it feels incomplete and needs something extra, I write down a word, a line from a poem or quote that ties the image all together with the feelings behind it expressed in words. Ultimately, this is a personal choice.

The materials I choose have to do with the work itself. When I am working in a journal I will use waterproof ink pen. A piece with drips or fine lines lends itself to a fine-tipped ink pen such as a Micron 005 or 01 for words written in small block print. If the piece is free form and flowing, I often opt for the black Stabilo All pencil or Caran d'Ache crayon loosely for words written in script. The personality of the work and the image dictate that the writing fit the expression.

Favorite Books

To Bless the Space Between Us by John O'Donohue
Risking Everything by Roger Housden
Rumi: Hidden Music translated by Azima M. Kolin and Maryam Mafi
New and Selected Poems Volumes One and Two by Mary Oliver

Quotes

brainyquote.com

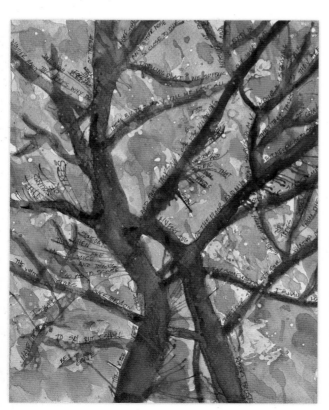

POEM EXCERPTS

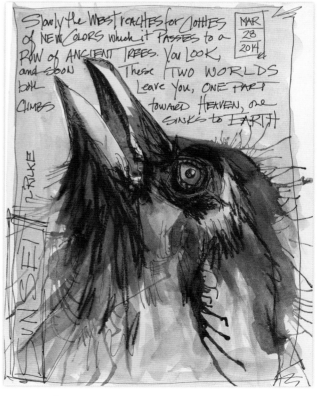

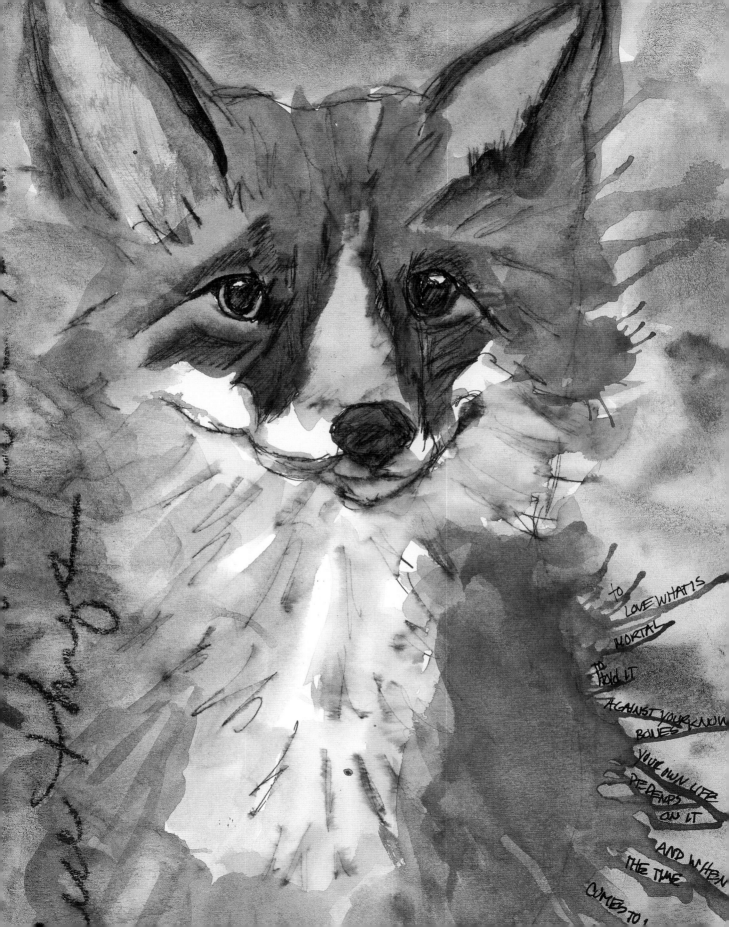

TO
LOVE WHAT IS
MORTAL
TO
HOLD IT
AGAINST YOUR KNOW
BONES
YOUR OWN LIFE
DEPENDS
ON IT

AND WHEN
THE TIME
COMES TO,

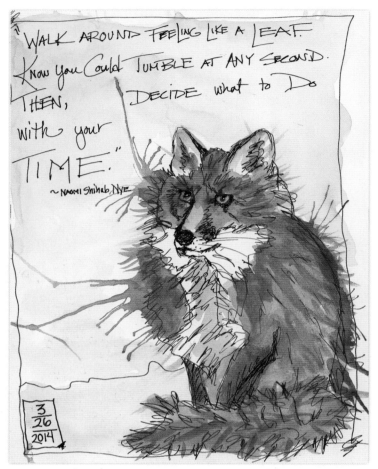

"WALK AROUND FEELING LIKE A LEAF.
Know You Could TUMBLE AT ANY SECOND.
Then, DECIDE what to Do
with your
TIME."
~ NAOMI Shihab, Nye

3
26
2014

QUOTES

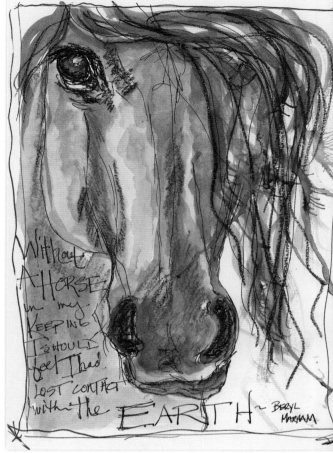

Without A HORSE in my KEEPING I SHOULD feel I had LOST CONTACT with the EARTH ~ BERYL MARKHAM

JOURNALING

MAY
18
2014

WORRYING GETS ME NOWHERE

SUNDAY MORNING AND FEELING RATHER ANXIOUS NOT REALLY KNOWING WHAT TO DO RELAX AND ENJOY OK DO STUFF I NEED TO DO — SUNDAYS CAN BE HARD AS I OFTEN FEEL BLUE AND DEPRESSED ANXIOUS ABOUT THE WEEK TO COME. IF I COULD ONLY STOP THIS INCESSANT WORRYING — I DO THIS TO MYSELF AND I NEED TO QUIET MY MIND — WHAT HELPS — SKETCHING, RIDING MEDITATING, WALKING, READING SO WHY DON'T I DO IT ON A REG BASIS WHY THE SELF SABOTAGE? WORRYING GETS ME NOWHERE.

Inspiration
Source Guide

The following section of the book is meant as a resource guide for your inspiration. Sometimes we stare at a blank page and don't know where to start. "What should I work on? What inspires me? I am drawing a blank!" So I encourage you to flip through the pages and find one that speaks to you (you don't have to go in order!). You will find ideas, quotes, poems, images, line drawings and finished pieces to get you moving!

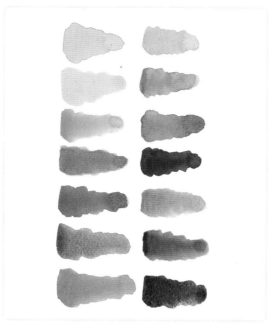

LINE DRAWINGS

Each section includes a line drawing for you to trace or transfer as a way of practicing your drawing. Visit CreateMixedMedia.com/no-excuses-watercolor to download these drawings.

COLOR PALETTE

A color palette with paint names is included to help guide you as you get started. Feel free to experiment with your own paint choices.

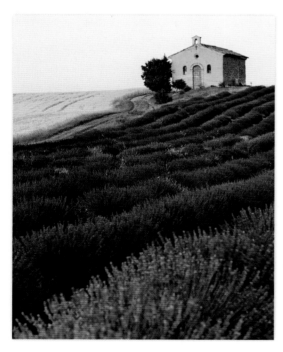

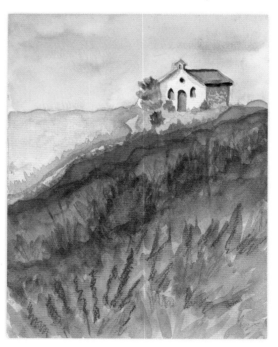

REFERENCE IMAGE

You'll also find a reference image, poems and quotes to use in your work and to ignite a spark of creativity.

FINISHED ART

Each section concludes with a finished piece to use as inspiration as you work on your own painting.

Spring

Subject Ideas

Lambs
Piglets
Chicks
Eggs
Seedlings
Daffodils
Irises
Tulips
Lilies of the valley
Cherry blossoms

Poetry Excerpts

To Spring
by William Blake
O thou with dewy locks, who lookest down
Through the clear windows of the morning, turn
Thine angel eyes upon our western isle,
Which in full choir hails thy approach, O Spring!

Young Lambs
by John Clare
A glittering star or two—till many trace
The edges of the blackthorn clumps in gold.
And then a little lamb bolts up behind
The hill and wags his tail to meet the yoe

Such Singing in the Wild Branches
by Mary Oliver
It was spring
And I finally heard him
Among the first leaves—
Then I saw him clutching the limb

Quotes

"Life stands before me like an eternal spring with new and
 brilliant clothes."
 —CARL FRIEDRICH GAUSS

"You can cut all the flowers but you cannot keep spring
 from coming."
 —PABLO NERUDA

"I trust in nature for the stable laws of beauty and utility.
 Spring shall plant and autumn garner to the end of time."
 —ROBERT BROWNING

"Spring has returned. The Earth is like a child that knows
 poems."
 —RAINER MARIA RILKE

"I am going to try to pay attention to the spring. I am going
 to look around at all the flowers, and look up at the hectic
 trees. I am going to close my eyes and listen."
 —ANNE LAMOTT

"Life without love is like a tree without blossoms or fruit."
 —KHALIL GIBRAN

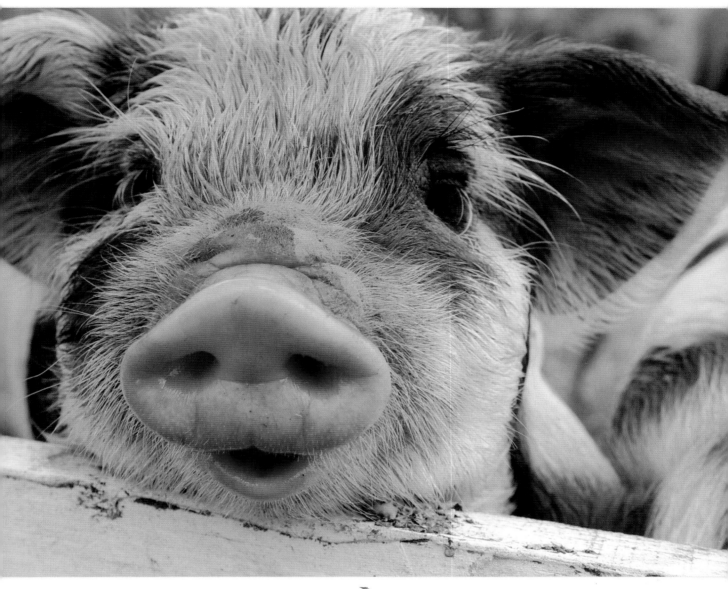

Color Palette

Left to right:
Brilliant Pink
Quinacridone Gold
Quinacridone Gold Deep
Phthalo Yellow Green
Shadow Violet
Sepia

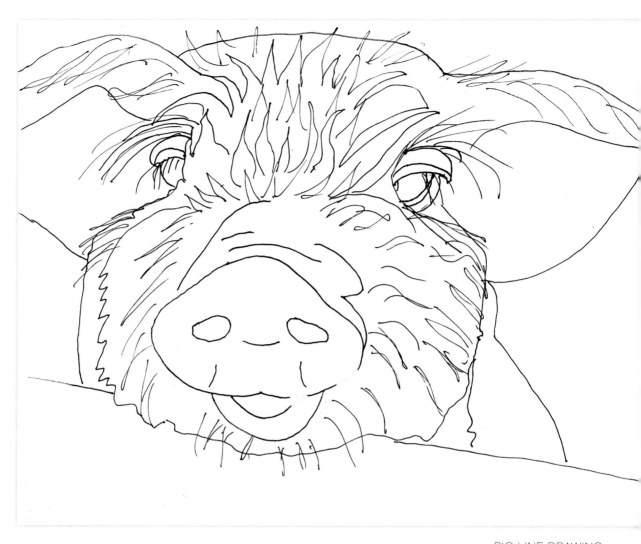

PIG LINE DRAWING

Find Bonus Content Online

Visit CreateMixedMedia.com/no-excuses-watercolor to download a PDF of this line drawing to use for practice.

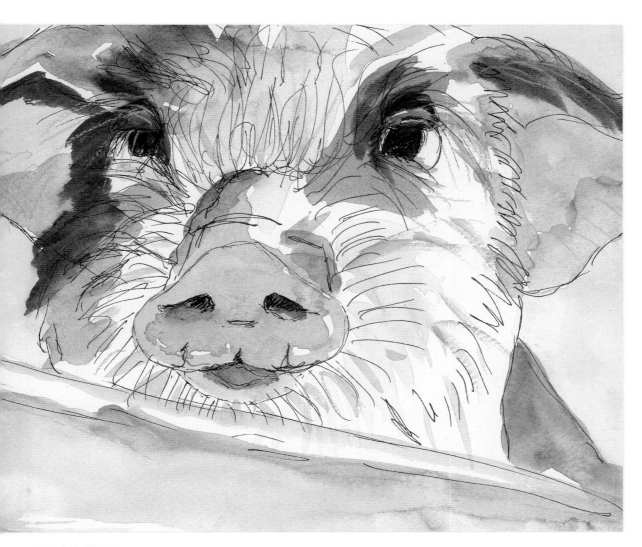

PIG PAINTING

Farm

Subject Ideas

Horses
Cows
Chickens
Ducks
Barns
Hayfields
Tractors
Fences
Pigs

Poetry Excerpts

The Cow in Apple Time
by Robert Frost
Something inspires the only cow of late
To make no more of a wall than an open gate,
And think no more of wall-builders than fools.
Her face is flecked with pomace and she drools
A cider syrup.

Four Horses
by David Whyte
I hear the whinny of
their fenced and abandoned
freedom
and feel happy
today
in the field
of my own making

Quotes

"A lovely horse is always an experience. It is an emotional experience of the kind that is spoiled by words."
—Beryl Markham

"Don't judge each day by the harvest you reap but by the seeds that you plant."
—Robert Louis Stevenson

"Cows are my passion. What I have ever sighed for has been to retreat to a Swiss farm, and live entirely surrounded by cows—and china."
—Charles Dickens

"The wide world is all about you: You can fence yourselves in, but you cannot forever fence it out."
—J.R.R. Tolkien

"Don't ever take a fence down until you know why it was put up."
—Robert Frost

"The wind of heaven is that which blows between a horse's ears."
—Arabian proverb

"Cows are amongst the gentlest of breathing creatures; none show more passionate tenderness to their young when deprived of them; and, in short, I am not ashamed to profess a deep love for these quiet creatures."
—Thomas De Quincey

"Animals are such agreeable friends—they ask no questions, they pass no criticisms."
—George Eliot

"Until one has loved an animal, a part of one's soul remains unawakened."
—Anatole France

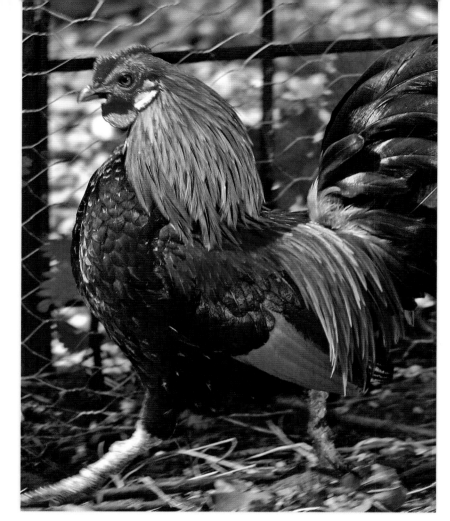

Color Palette

Row 1:
Quinacridone Gold
Quinacridone Gold Deep
Deep Scarlet
Serpentine
Phthalo Green
Cascade Green
Phthalo Turquoise

Row 2:
Bright Red
Naples Yellow
Caput Mortum
Payne's Gray
Ultramarine Blue
Shadow Violet
Peacock Blue

ROOSTER LINE DRAWING

Find Bonus Content Online

Visit CreateMixedMedia.com/no-excuses-watercolor to
download a PDF of this line drawing to use for practice.

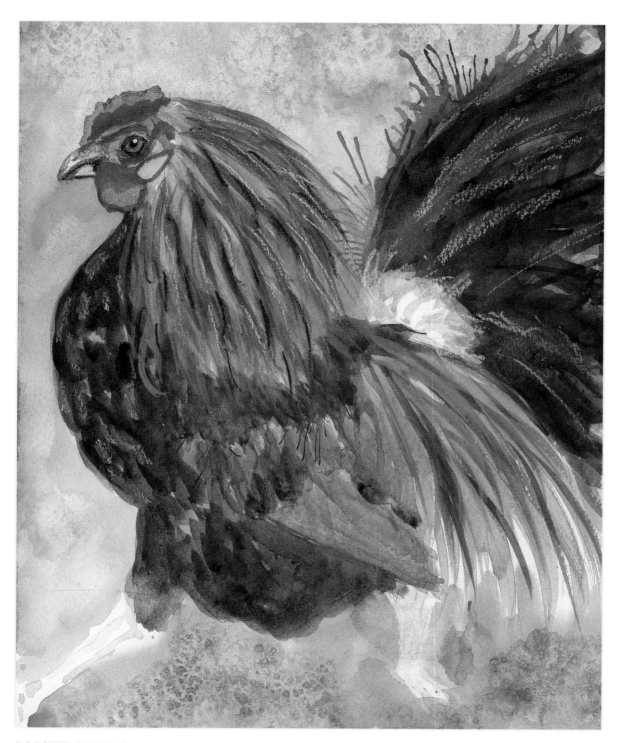

ROOSTER PAINTING

England

Subject Ideas

Big Ben
Red telephone box
High tea
River Thames
English gardens
British flag
Country manor
Buckingham Palace
Double-decker bus

Poetry Excerpts

Happy Is England
by John Keats
Happy is England! I could be content
To see no other verdure than its own;
To feel no other breezes than are blown
Through its tall woods with high romances blent:

The English Country Lane
by Chris Plows
There is no path I'd rather roam,
than these narrow lanes about my home,
to leave my troubles far behind,
as I follow its track to places kind.

Quotes

"There are few hours in life more agreeable than the hour dedicated to the ceremony known as afternoon tea."
—Henry James

"You can't get a cup of tea big enough or a book long enough to suit me."
—C.S. Lewis

"By seeing London, I have seen as much of life as the world can show."
—Samuel Johnson

"The man who can dominate a London dinner-table can dominate the world."
—Oscar Wilde

"When it's three o' clock in New York, it's still 1938 in London."
—Bette Midler

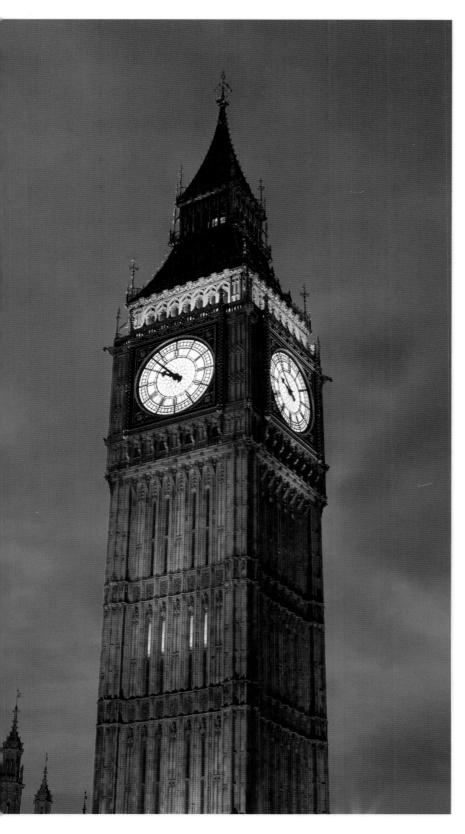

Color Palette

Top to bottom:
Pyrrole Orange
Quinacridone Gold
Quinacridone Gold Deep
Phthalo Yellow Green
Peacock Blue
Moonglow
Lunar Violet
Hematite

ENGLAND LINE DRAWING

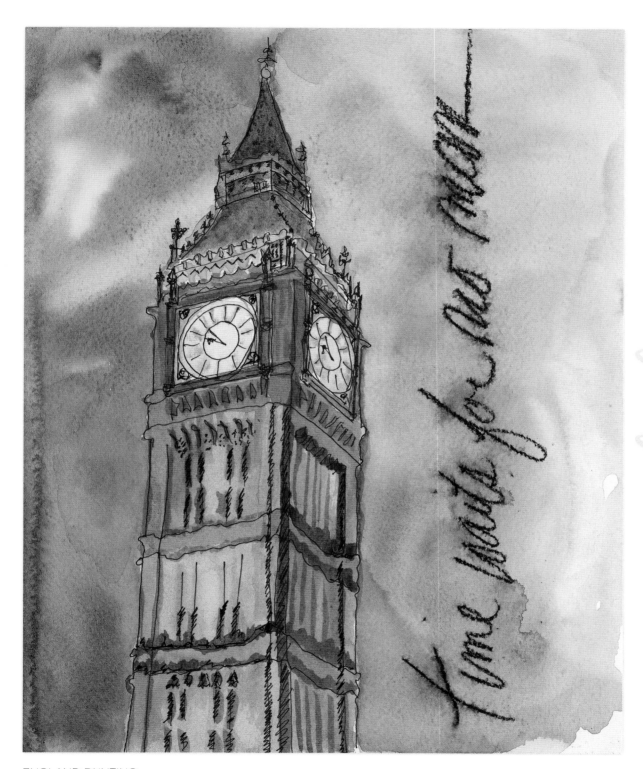

ENGLAND PAINTING

France

Subject Ideas

Provence
Lavender fields
Paris
Eiffel Tower
Monet
Cheese
Champagne
Pastries
Versailles
Arc de Triomphe
Louvre Museum

Poetry Excerpts

Inventory
by Dorothy Parker
Four be the things I'd been better without:
Love, curiosity, freckles, and doubt.
Three be the things I shall never attain:
Envy, content, and sufficient champagne.

Paris
by Alan Seeger
First, London, for its myriads; for its height,
Manhattan heaped in towering stalagmite;
But Paris for the smoothness of the paths
That lead the heart unto the heart's delight. . . .

Quotes

"If you are lucky enough to have lived in Paris as a young man, then wherever you go for the rest of your life it stays with you, for Paris is a moveable feast."
—Ernest Hemingway

"Paris is always a good idea."
—Audrey Hepburn

"An artist has no home in Europe except in Paris."
—Friedrich Nietzsche

"In France, cooking is a serious art form and a national sport."
—Julia Child

"Come quickly, I am tasting the stars!"
—Dom Pérignon

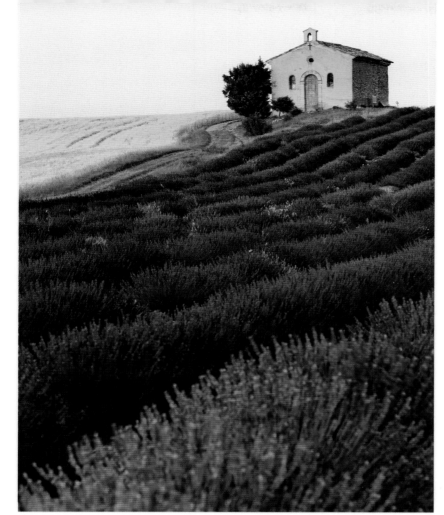

Color Palette

Row 1:
Yellow Ochre
Quinacridone Nickel Azo Gold
Phthalo Yellow Green
Sap Green
Deep Sap Green
Burnt Sienna
Raw Umber

Row 2:
Horizon Blue
Peacock Blue
Mineral Violet
Naphthamide Maroon
Opera Pink
Quinacridone Violet
Lunar Violet

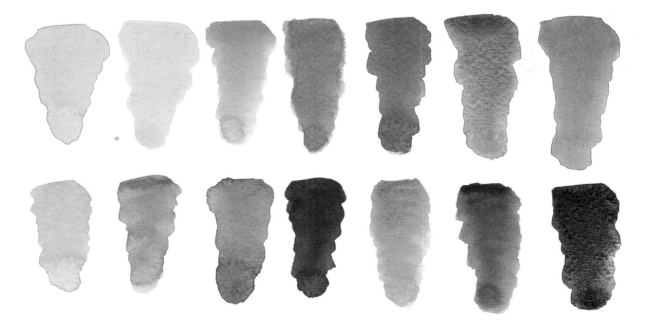

FRANCE LINE DRAWING

Find Bonus Content Online

Visit CreateMixedMedia.com/no-excuses-watercolor to download a PDF of this line drawing to use for practice.

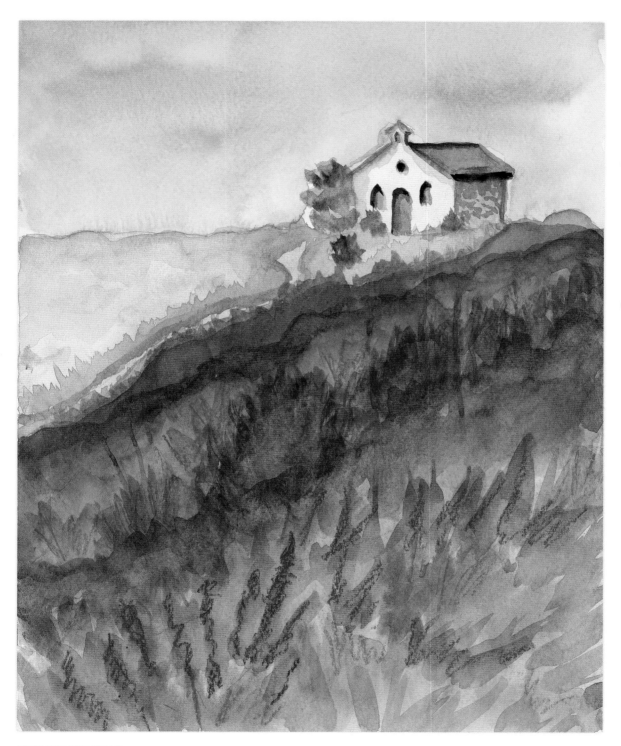

FRANCE PAINTING

Italy

Subject Ideas

Pasta
Wine
Tuscany
Venice
Florence
Rome
Vatican
Sistine Chapel
Amalfi Coast
Coliseum
Uffizi Gallery

Poetry Excerpts

Sonnet on Approaching Italy
by Oscar Wilde
I reached the Alps: the soul within me burned
Italia, my Italia, at thy name:
And when from out the mountain's heart I came
And saw the land for which my life had yearned

Farewell to Italy
by Alfred Austin
Incomparable Italy, farewell!
Tears not unmanly trespass to the eyes,
From thy soft touch and glance unspeakable
Compelled to turn and suffer other skies.

Quotes

"You may have the universe if I may have Italy."
—Giuseppe Verdi

"The Creator made Italy from designs by Michelangelo."
—Mark Twain

"Italy, and the spring and first love all together should suffice to make the gloomiest person happy."
—Bertrand Russell

"A man who has not been in Italy, is always conscious of an inferiority, from his not having seen what it is expected a man should see."
—Samuel Johnson

"Venice is like eating an entire box of chocolate liqueurs in one go."
—Truman Capote

"White swan of cities slumbering in thy nest . . . White phantom city, whose untrodden streets Are rivers, and whose pavements are the shifting Shadows of the palaces and strips of sky."
—Henry Wadsworth Longfellow

"Methinks I will not die quite happy without having seen something of that Rome of which I have read so much."
—Sir Walter Scott

Color Palette

Row 1:
Cadmium Yellow
New Gamboge
Chinese Orange
Quinacridone Gold
Quinacridone Gold Deep
Deep Scarlet
Carmine

Row 2:
Ultramarine Blue
Smalt Blue
Mineral Violet
Piemontite Genuine
Shadow Violet
Phthalo Yellow Green

ITALY LINE DRAWING

Find Bonus Content Online

Visit CreateMixedMedia.com/no-excuses-watercolor to download a PDF of this line drawing to use for practice.

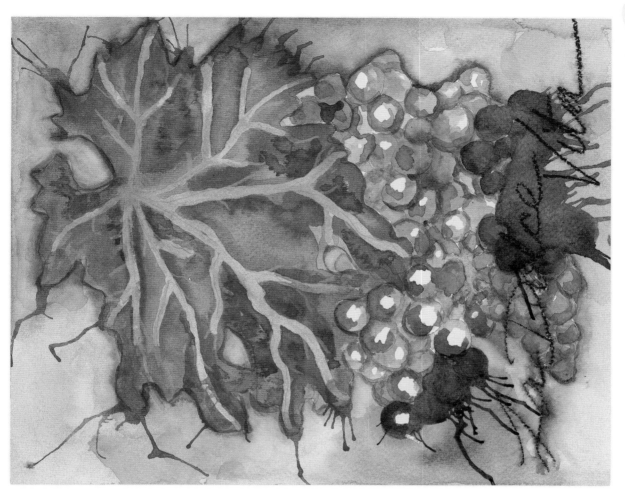

ITALY PAINTING

Summer

Subject Ideas

Watermelon
Lemonade
Seashore
Barbeque
Books
Picnic
Vacation
Fireflies
Camping

Poetry Excerpts

Summer Images
by John Clare
Now swarthy Summer, by rude health embrowned,
 Precedence takes of rosy fingered Spring;
And laughing Joy, with wild flowers prank'd, and crown'd,
 A wild and giddy thing,

Psalm of the Day
by Emily Dickinson
A something in a summer's noon—
A depth—an Azure—a perfume—
Transcending ecstasy.

Quotes

"And so with the sunshine and the great bursts of leaves growing on the trees, just as things grow in fast movies, I had that familiar conviction that life was beginning over again with the summer."
—F. Scott Fitzgerald, *The Great Gatsby*

"I almost wish we were butterflies and liv'd but three summer days—three such days with you I could fill with more delight than fifty common years could ever contain."
—John Keats

"Summer afternoon—summer afternoon; to me those have always been the two most beautiful words in the English language."
—Henry James

"I know I am but summer to your heart, and not the full four seasons of the year."
—Edna St. Vincent Millay

"What good is the warmth of summer, without the cold of winter to give it sweetness."
—John Steinbeck

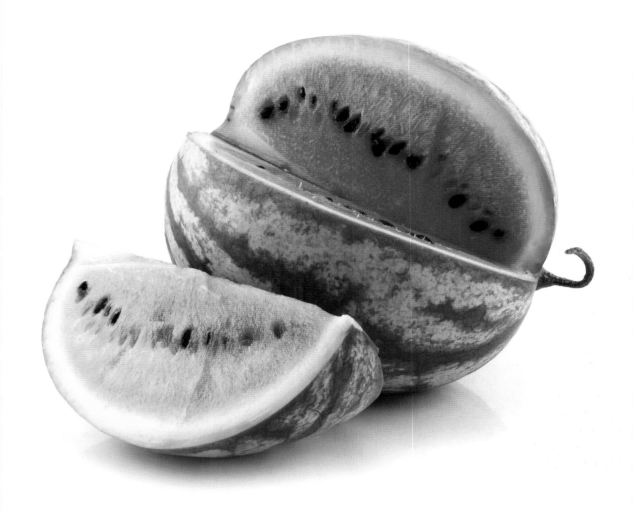

Color Palette

Left to right:
Phthalo Yellow Green
Chromium Green Oxide
Green Apatite
Bright Red
Scarlet Lacquer
Shadow Violet
Sepia

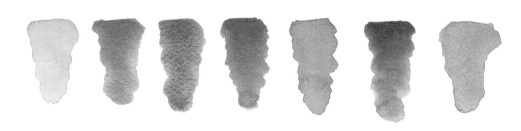

WATERMELON LINE DRAWING

Find Bonus Content Online

Visit CreateMixedMedia.com/no-excuses-watercolor to download a PDF of this line drawing to use for practice.

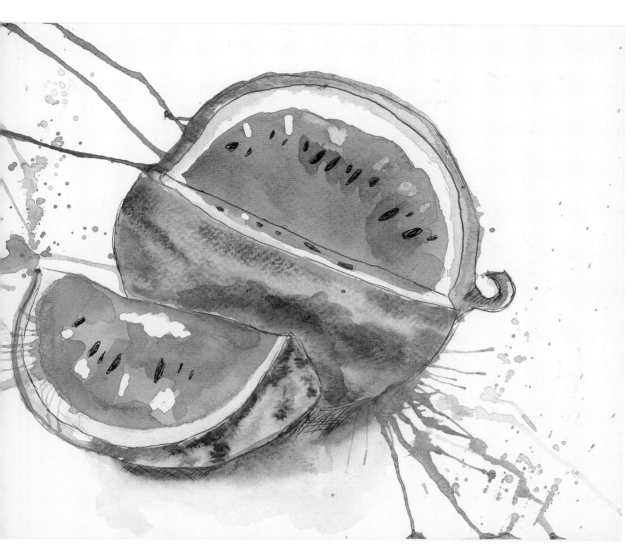

WATERMELON PAINTING

Autumn

Subject Ideas

Leaves
Apples
Harvest moon
Schoolbooks
Pumpkins
Sweaters
Acorns
Black cats
Sunflowers
Country roads

Poetry Excerpts

The Road Not Taken
by Robert Frost
Two roads diverged in a yellow wood,
And sorry I could not travel both
And be one traveler, long I stood
And looked down one as far as I could

Song for Autumn
by Mary Oliver
In the deep fall
 don't you imagine the leaves think how
comfortable it will be to touch
 the earth instead of the
nothingness of air and the endless
 freshets of wind?

Quotes

"Autumn is a second spring when every leaf is a flower."
—Albert Camus

"I'm so glad I live in a world where there are Octobers."
—L.M. Montgomery, *Anne of Green Gables*

"I would rather sit on a pumpkin, and have it all to myself, than be crowded on a velvet cushion."
—Henry David Thoreau

"No spring nor summer beauty hath such grace as I have seen in one autumnal face."
—John Donne

"Autumn. . . the year's last, loveliest smile."
—William Cullen Bryant

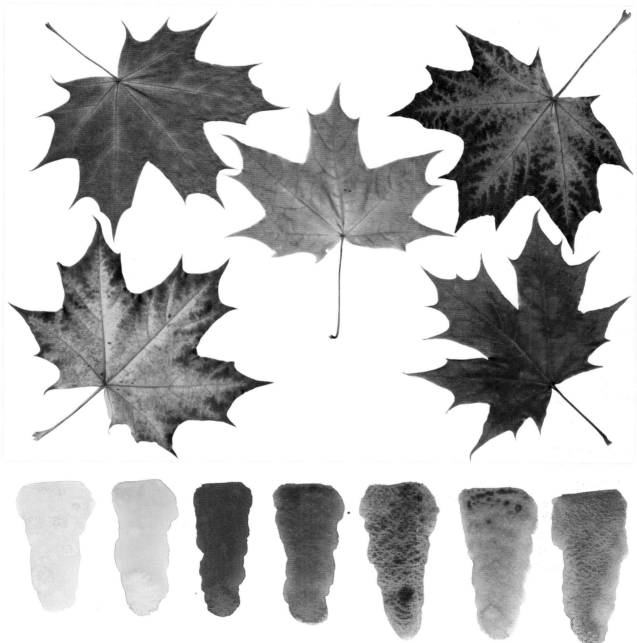

Color Palette

Left to right:
Lemon Yellow
New Gamboge
Bordeaux
Deep Scarlet
Bloodstone Genuine
Serpentine
Green Apatite

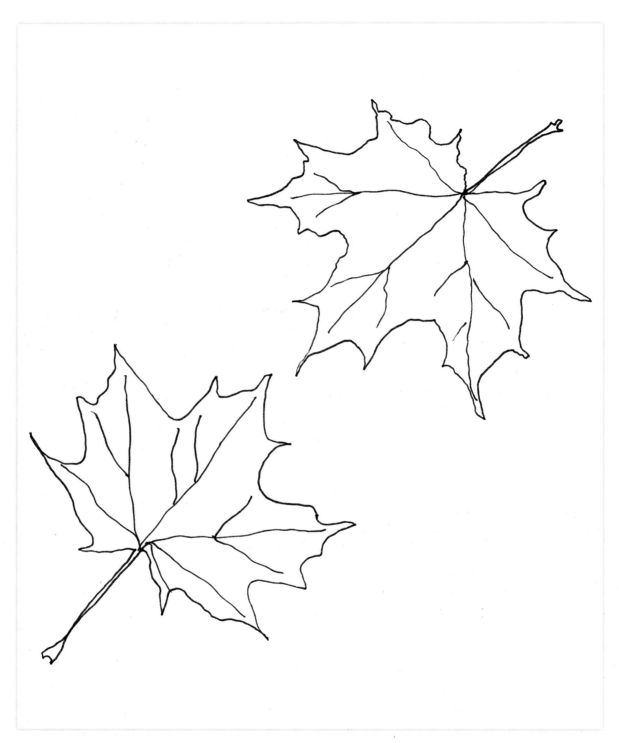

LEAVES LINE DRAWING

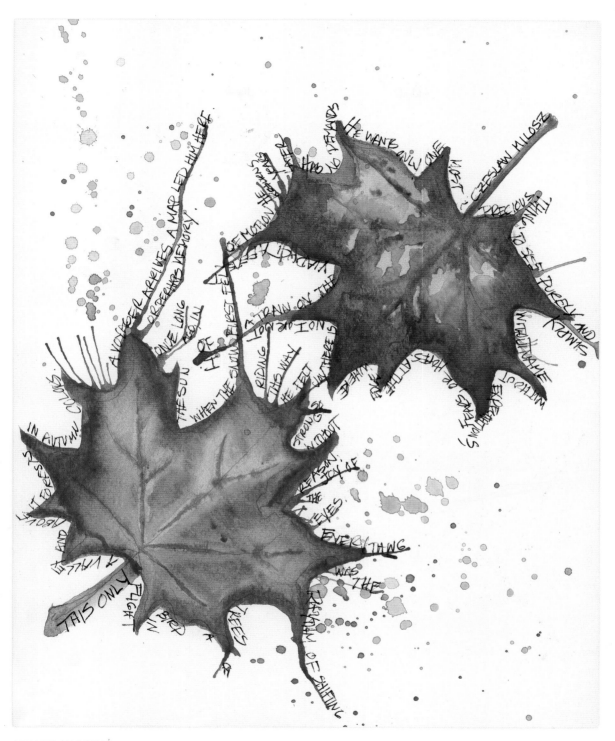

LEAVES PAINTING

Winter

Subject Idea

Snow
Snowflakes
Icicles
Christmas
Pinecones
Holly
Fireplaces
Candlelight
Nutmeg
Hot cocoa
Mittens

Poetry Excerpts

First Snow
by Mary Oliver
Trees
glitter like castles
of ribbons, the broad fields
smolder with light, a passing
creekbed lies
heaped with shining hills;

The Winter of Listening
by David Whyte
So let this winter
of listening
be enough
for the new life
I must call my own.

Quotes

"In the depth of winter I finally learned that there was in me an invincible summer."
—Albert Camus

"No winter lasts forever; no spring skips its turn."
—Hal Borland

"I wonder if the snow loves the trees and fields, that it kisses them so gently? And then it covers them up snug, you know, with a white quilt; and perhaps it says 'Go to sleep, darlings, till the summer comes again.'"
—Lewis Carroll

"Winter is the time for comfort, for good food and warmth, for the touch of a friendly hand and for a talk beside the fire: it is the time for home."
—Edith Sitwell

"What good is the warmth of summer, without the cold of winter to give it sweetness."
—John Steinbeck

"I do an awful lot of thinking and dreaming about things in the past and the future—the timelessness of the rocks and the hills—all the people who have existed there. I prefer winter and fall, when you feel the bone structure of the landscape—the loneliness of it, the dead feeling of winter. Something waits beneath it, the whole story doesn't show."
—Andrew Wyeth

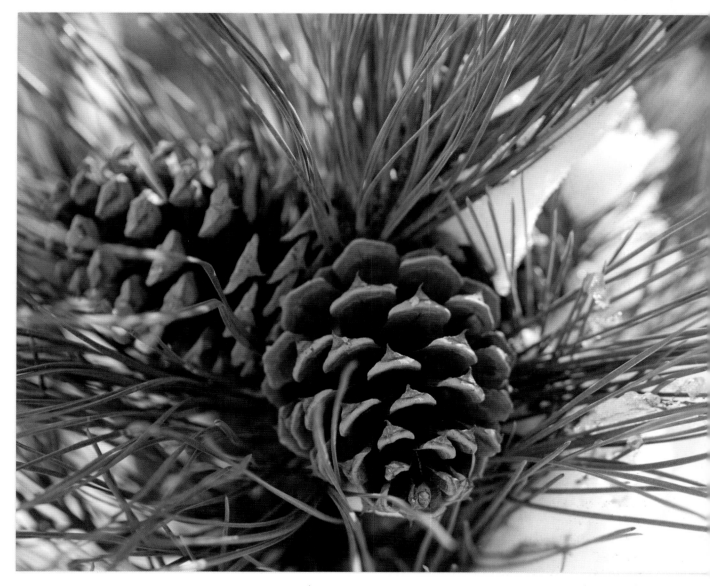

Color Palette

Left to right:
Tiger's Eye Genuine
Sepia
Burnt Umber
Sap Green
Deep Sap Green

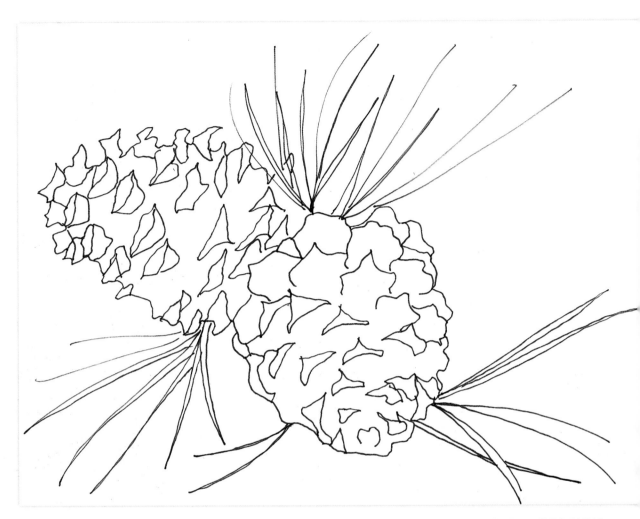

PINECONE LINE DRAWING

Find Bonus Content Online

Visit CreateMixedMedia.com/no-excuses-watercolor to download a PDF of this line drawing to use for practice.

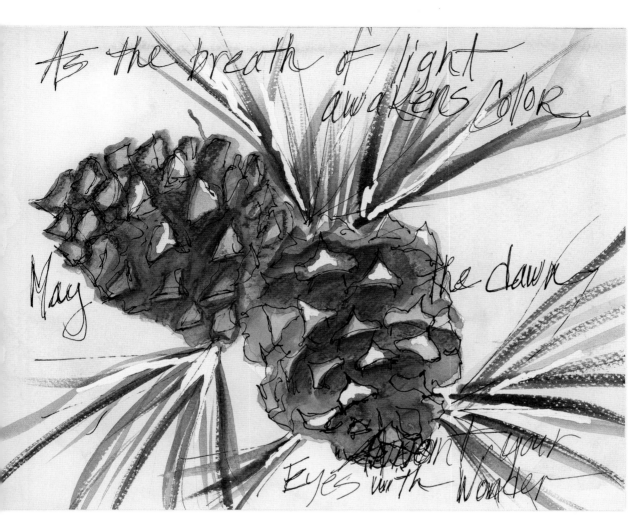

As the breath of light awakens color

May the dawn

Eyes with Wonder

PINECONE PAINTING

Birds

Subject Ideas

Owls
Robins
Cardinals
Blackbirds
Ravens
Blue jays
Herons
Hawks
Hummingbirds

Poetry Excerpts

Wild Geese
by Mary Oliver
Meanwhile the wild geese, high in the clean blue air,
are heading home again.
Whoever you are, no matter how lonely,
the world offers itself to your imagination

Red Bird
by Mary Oliver
So come to the pond,
or the river of your imagination, or the harbor of your long-
ing,
and put your lips to the world.
And live your life.

Quotes

"The reason birds can fly and we can't is simply because
they have perfect faith, for to have faith is to have wings."
—J.M. Barrie

"In order to see birds it is necessary to become a part of
the silence."
—Robert Lynd

"In order to arrive at knowledge of the motions of birds
in the air, it is first necessary to acquire knowledge of the
winds."
—Leonardo da Vinci

"A bird doesn't sing because it has an answer,
it sings because it has a song."
—Maya Angelou

"You were born with wings, why prefer to crawl through
life?"
—Rumi

"I am no bird, and no net ensnares me, I am a free human
being with an independent will."
—Charlotte Brontë

"Intelligence without ambition is like a bird without wings."
—Salvador Dalí

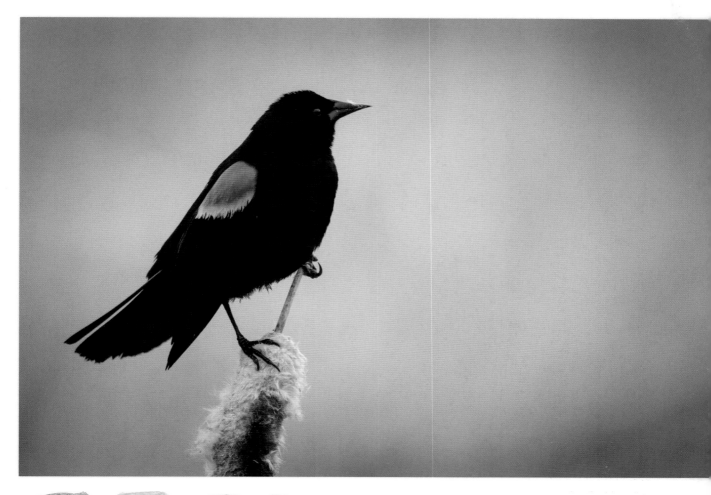

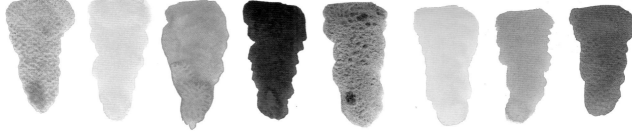

Color Palette

Left to right:
Tiger's Eye Genuine
Brilliant Pink
Horizon Blue
Sepia
Sodalite
Cadmium Yellow Medium
Pyrrole Orange
Burnt Sienna

BIRD LINE DRAWING

Find Bonus Content Online

Visit CreateMixedMedia.com/no-excuses-watercolor to download a PDF of this line drawing to use for practice.

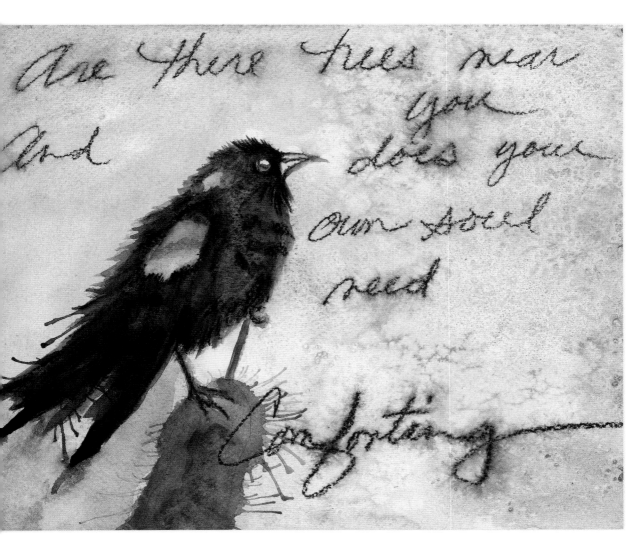

BIRD PAINTING

Sea

Subject Ideas

Seashells
Shoreline
Octopus
Sea urchins
Pelicans
Seagulls
Waves
Sea glass
Whales
Fish
Kelp

Poetry Excerpts

The Mermaid
by Alfred, Lord Tennyson
I would be a mermaid fair;
I would sing to myself the whole of the day;
With a comb of pearl I would comb my hair;

Oceans
by Juan Ramón Jiménez
I have a feeling that my boat has struck, down there in the depths,
Against a great thing.

Quotes

"The sea, once it casts its spell, holds one in its net of wonder forever."
—Jacques-Yves Cousteau

"The sea does not reward those who are too anxious, too greedy, or too impatient. One should lie empty, open, choiceless as a beach—waiting for a gift from the sea."
—Anne Morrow Lindbergh

"My soul is full of longing
for the secret of the sea,
and the heart of the great ocean
sends a thrilling pulse through me."
—Henry Wadsworth Longfellow

"I need the sea because it teaches me."
—Pablo Neruda

"Live in the sunshine, swim in the sea, drink the wild air."
—Ralph Waldo Emerson

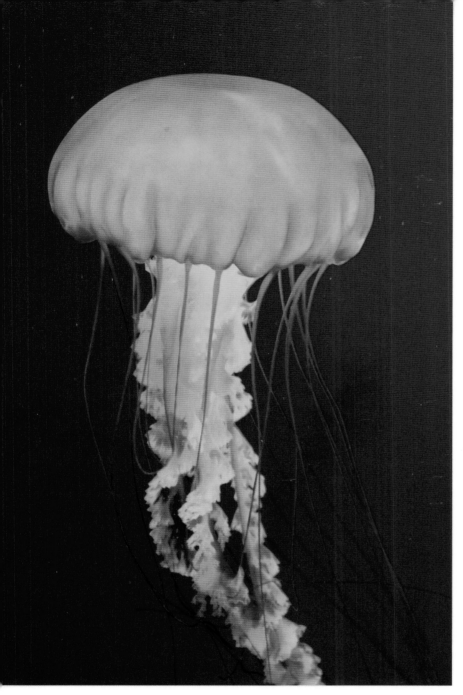

Color Palette

Top to bottom:
Phthalo Blue
Moonglow
Shadow Violet
Cadmium Yellow
New Gamboge
Quinacridone Gold
Chinese Orange
Carmine
Deep Scarlet

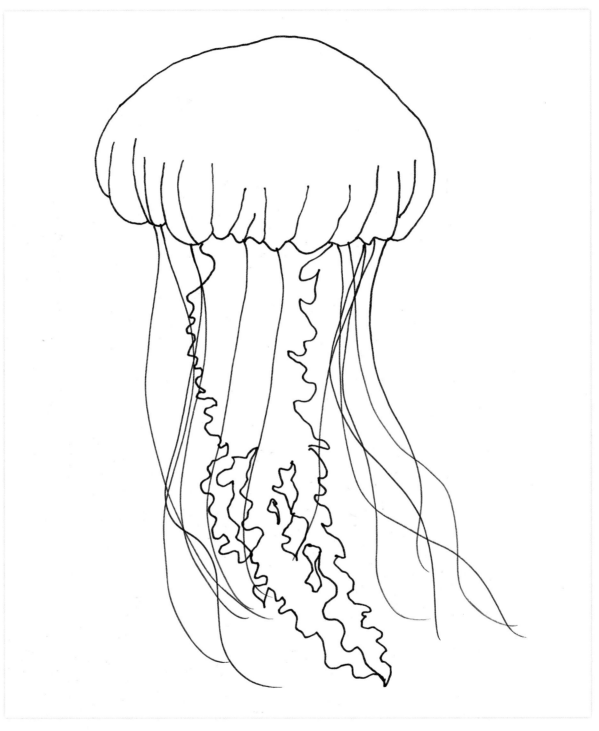

JELLYFISH LINE DRAWING

Find Bonus Content Online

Visit CreateMixedMedia.com/no-excuses-watercolor to download a PDF of this line drawing to use for practice.

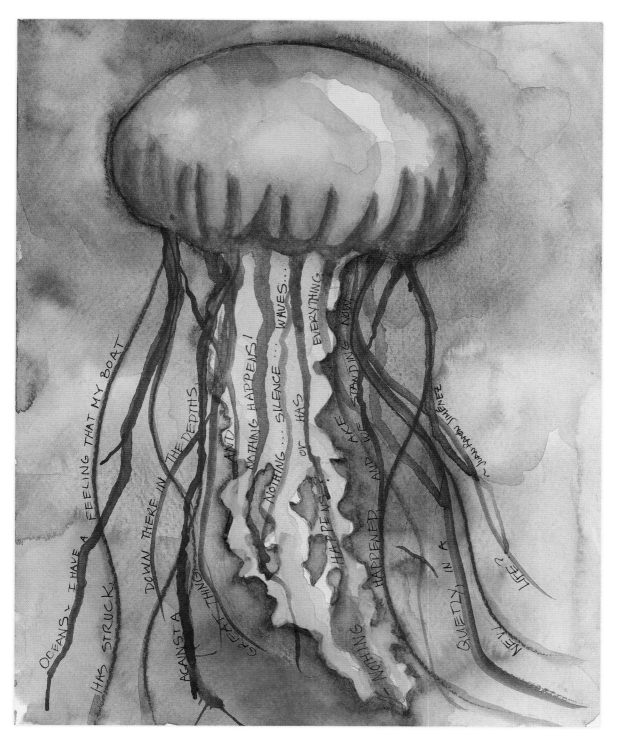

JELLYFISH PAINTING

Mexico

Subject Ideas

Frida Kahlo
Sombrero
Pyramid of the Moon in Teotihuacan
Chiles
Cabo San Lucas
Piñata
Calaveras
Lotería cards
Burro
Our Lady of Guadalupe
Pancho Villa
Cuauhxicalli—sunstone
Paper flowers
Sugar skulls
Diego Rivera

Poetry Excerpts

April in Mexico
by Michael Hogan
It is the time of the jacaranda
when streets are violet carpets
and venders call "Hay elotes!" in the early evening.
No reason to think this could not last forever

Mexico
by Ina D. Coolbrith
O strange new world that was the old!
O strange old world that was the young!
That greeted from strange altar fires,
From strange new gods, with strange new tongue!

Quotes

"My sole ambition is to rid Mexico of the class that has oppressed her and give the people a chance to know what real liberty means. And if I could bring that about today by giving up my life, I would do it gladly."
—Pancho Villa

"Feet, what do I need you for when I have wings to fly?"
—Frida Kahlo

"I paint my own reality. The only thing I know is that I paint because I need to, and I paint whatever passes through my head without any other consideration."
—Frida Kahlo

"Every good composition is above all a work of abstraction. All good painters know this. But the painter cannot dispense with subjects altogether without his work suffering impoverishment."
—Diego Rivera

Color Palette

Row 1:
Horizon Blue
Sodalite
Moonglow
Cadmium Yellow
Brilliant Pink

Row 2 (water-soluble pencils):
Pink
Yellow
Light Blue

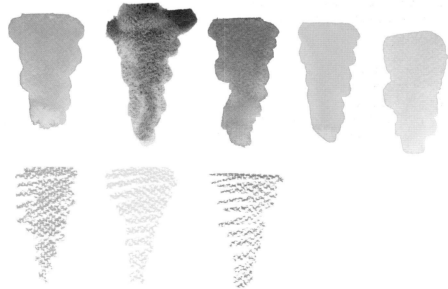

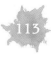

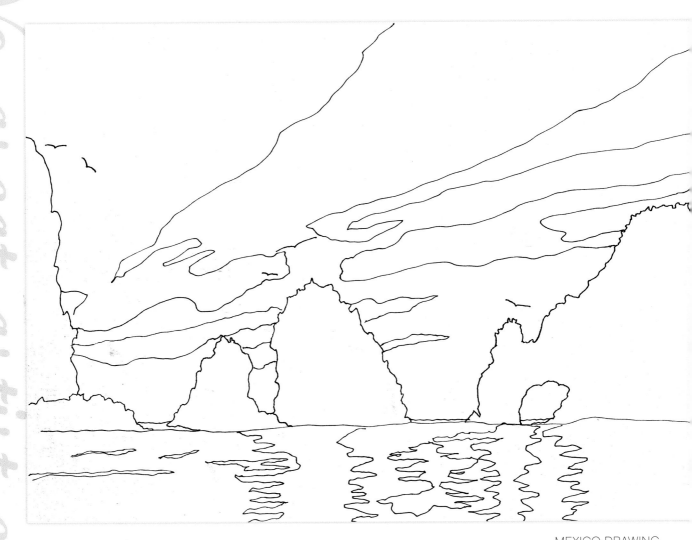

MEXICO DRAWING

Find Bonus Content Online

Visit CreateMixedMedia.com/no-excuses-watercolor to
download a PDF of this line drawing to use for practice.

MEXICO PAINTING

Gardens

Subject Ideas

Tomatoes
Beets
Carrots
Corn
Rain boots
Watering can
Gardening gloves
Rabbits
Scarecrows
Rake
Pitchfork
Wheelbarrow
Cabbage

Poetry Excerpts

The Glory of the Garden
by Rudyard Kipling
For where the old thick laurels grow, along the thin red wall,
You will find the tool- and potting-sheds which are the
heart of all;
The cold-frames and the hot-houses, the dungpits and the
tanks:
The rollers, carts and drain-pipes, with the barrows and the
planks.

My Garden
by Emily Dickinson
New feet within my garden go,
New fingers stir the sod;
A Troubadour upon the Elm
Betrays the solitude.

Quotes

"Show me your garden and I shall tell you what you are."
—Alfred Austin

"If you have a garden and a library, you have everything
you need."
—Marcus Tullius Cicero

"A garden requires patient labor and attention. Plants do
not grow merely to satisfy ambitions or to fulfill good inten-
tions. They thrive because someone expended effort on
them."
—Liberty Hyde Bailey

"What is a weed? A plant whose virtues have never been
discovered."
—Ralph Waldo Emerson

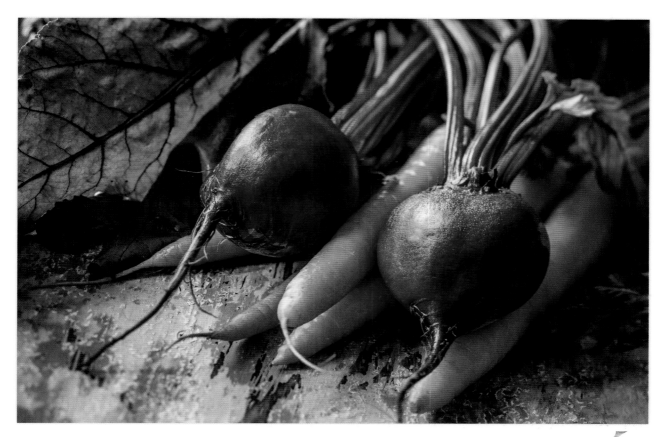

Color Palette

Row 1:
Serpentine
Green Apatite
Crimson Lake
Carmine
Opera Pink

Row 2:
Pyrrole Orange
Quinacridone Gold Deep
Naphthol Maroon
Shadow Violet

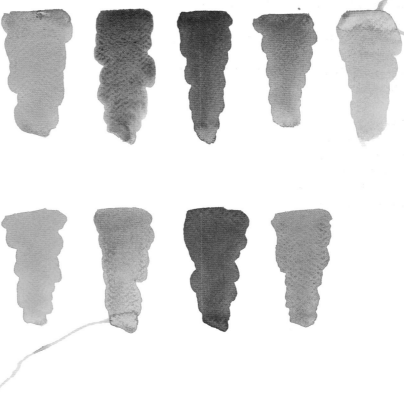

GARDEN LINE DRAWING

Find Bonus Content Online

Visit CreateMixedMedia.com/no-excuses-watercolor to download a PDF of this line drawing to use for practice.

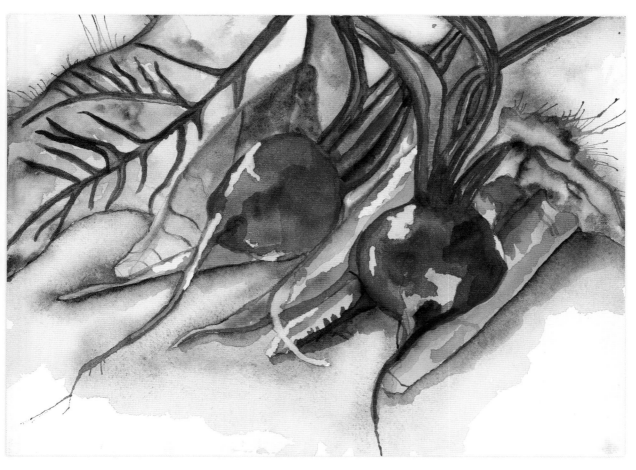

GARDEN PAINTING

Forest

Subject Ideas

Chipmunks
Pine trees
Logs
Ferns
Wildflowers
Camping gear
Squirrels
Deer
Bears
Pinecones
Lake
Cabins

Poetry Excerpts

Sleeping In The Forest
by Mary Oliver
I thought the earth remembered me, she
took me back so tenderly, arranging
her dark skirts, her pockets
full of lichens and seeds.

The Wood
by Charlotte Brontë
Sit then, awhile, here in this wood
So total is the solitude,
We safely may delay.

Quotes

"The clearest way into the Universe is through a forest wilderness."
—John Muir

"A forest bird never wants a cage."
—Henrik Ibsen

"It is not so much for its beauty that the forest makes a claim upon men's hearts, as for that subtle something, that quality of air, that emanation from old trees, that so wonderfully changes and renews a weary spirit."
—Robert Louis Stevenson

"When the oak is felled the whole forest echoes with its fall, but a hundred acorns are sown in silence by an unnoticed breeze."
—Thomas Carlyle

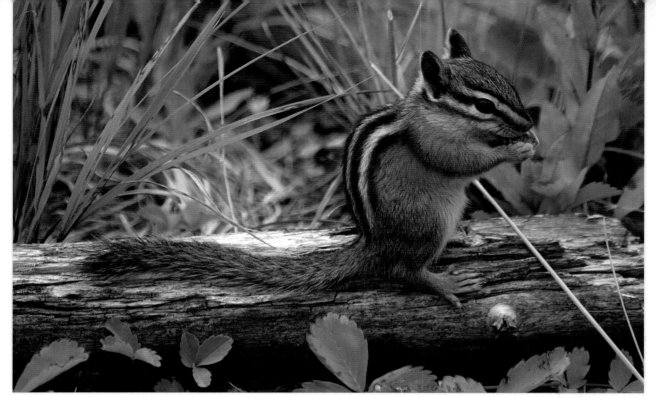

Color Palette

Row 1:
Yellow Ochre
Quinacridone Gold
Quinacridone Gold Deep
Tiger's Eye
Raw Umber

Row 2:
Burnt Umber
Hematite
Zoisite
Sodalite
Gold Green

Row 3:
Serpentine
Green Apatite
Scarlet Lake

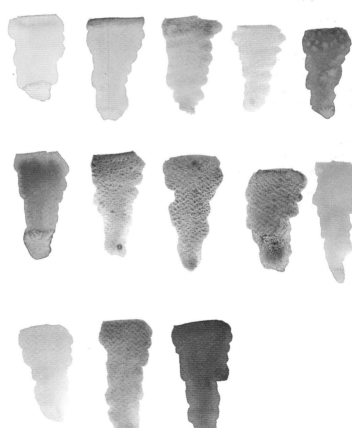

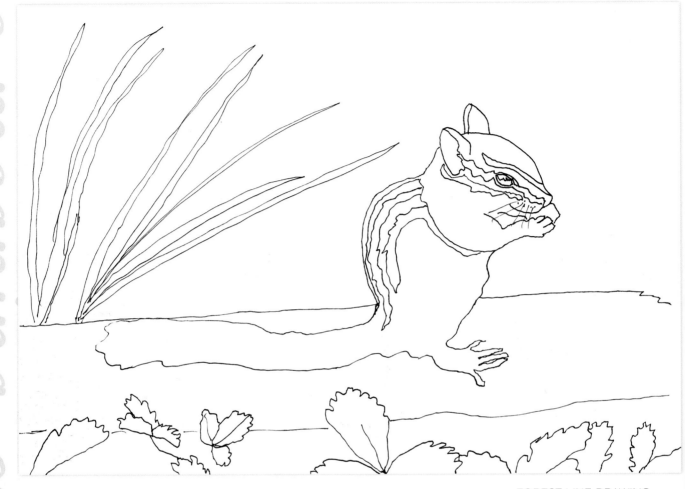

FOREST LINE DRAWING

Find Bonus Content Online

Visit CreateMixedMedia.com/no-excuses-watercolor to download a PDF of this line drawing to use for practice.

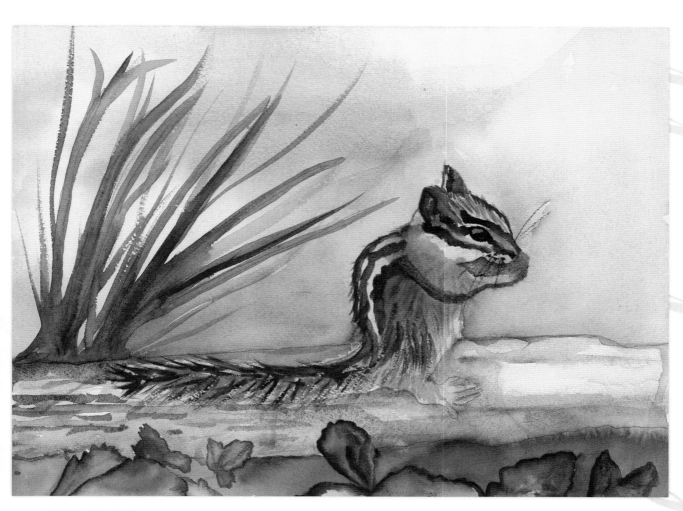

FOREST PAINTING

About the Author

Gina Rossi Armfield is a painter, photographer, wife and mother. She lives in Southern California with her husband, Mark, two sons, Grayson and Payton, and a herd of furry critters. Gina started painting when she was six years old and was lucky enough to find many mentors along the way who encouraged her to pursue her talents. She grew up in Baltimore, Maryland, and in addition to painting, spent most of her time riding and showing horses. A passion for the four-leggeds endures to this day and can be seen in much of her work. Gina received her degrees in fine art and education. She has taught people of all ages and continues to enrich her life by sharing her gifts with others.

Gina is the author of *No Excuses Art Journaling* (North Light, 2013) and host of two North Light mixed-media instructional videos: *Art Journaling With Gina Rossi Armfield: The No Excuses Approach to Drawing and Watercolor*, and *Art Journaling With Gina Rossi Armfield: The No Excuses Approach to Mixed-Media Collage*. Gina can be found teaching around the country and through her online eCourses. You can find her on her website noexcusesart.com.

Acknowledgments

I would like to thank my friends and family for their love, support and guidance. To my mentors along the way who believed in me and encouraged me to pursue my dreams. To Amy Jones, my editor, for being kind, patient, witty, sharp and caring. Your name is in a binder somewhere I am sure! And to all of God's furry and feathered creatures who continue to inspire and ground me everyday.

Dedication

I dedicate this book to Mark, Grayson and Payton, and my four-legged soul mates. And to Creus, for healing my broken heart in a way that no one else could.

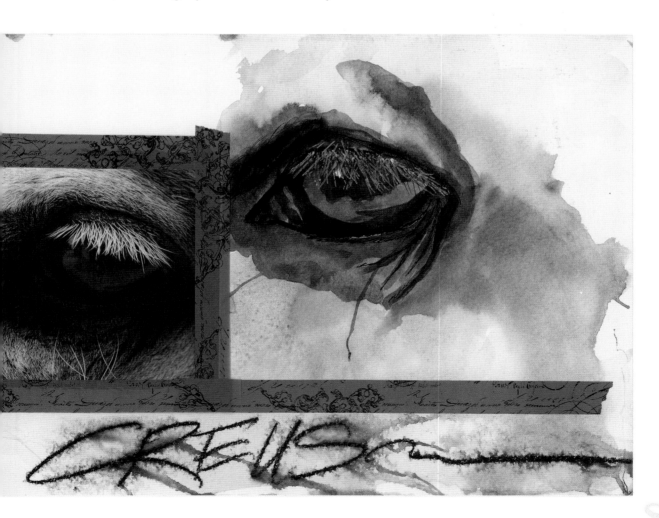

Index

Other fine North Light Books are available from your favorite bookstore, art supply store or online supplier. Visit our website at fwcommunity.com.

19 18 17 16 15 5 4 3 2 1

a content + ecommerce company

DISTRIBUTED IN CANADA BY FRASER DIRECT
100 Armstrong Avenue
Georgetown, ON, Canada L7G 5S4
Tel: (905) 877-4411

DISTRIBUTED IN THE U.K. AND EUROPE BY F&W MEDIA INTERNATIONAL LTD
Brunel House, Forde Close, Newton Abbot, TQ12 4PU, UK
Tel: (+44) 1626 323200, Fax: (+44) 1626 323319
Email: enquiries@fwmedia.com

DISTRIBUTED IN AUSTRALIA BY CAPRICORN LINK
P.O. Box 704, S. Windsor NSW, 2756 Australia
Tel: (02) 4560-1600; Fax: (02) 4577 5288
Email: books@capricornlink.com.au

ISBN 13: 978-1-4403-3985-1

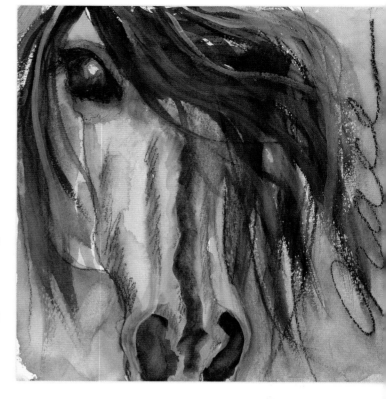

Metric Conversion Chart

TO CONVERT	TO	MULTIPLY BY
Inches	Centimeters	2.54
Centimeters	Inches	0.4
Feet	Centimeters	30.5
Centimeters	Feet	0.03
Yards	Meters	0.9
Meters	Yards	1.1

Edited by Amy Jones
Designed by Hannah Bailey
Production coordinated by Jennifer Bass
Photography by Christine Polomsky

Look. Make. Meet.

Visit CreateMixedMedia.com/no-excuses-watercolor to download line drawings from the inspiration source guide and other bonus material.

Find out more about Gina's mixed-media instructional videos and her first book at NorthLightShop.com!

 @CMixedMedia

 Follow CreateMixedMedia.com for the latest news, free wallpapers, free demos and chances to win FREE BOOKS!

 NLMixedMedia

 Search Create Mixed Media on Instagram.

Get your art in print!

Visit CreateMixedMedia.com for up-to-date information on Incite and other North Light competitions.